PHOTOSECRETS YOSEMITE

WHERE TO TAKE PICTURES

BY
ANDREW HUDSON

*"A good photograph
is knowing where to stand."*
— Ansel Adams

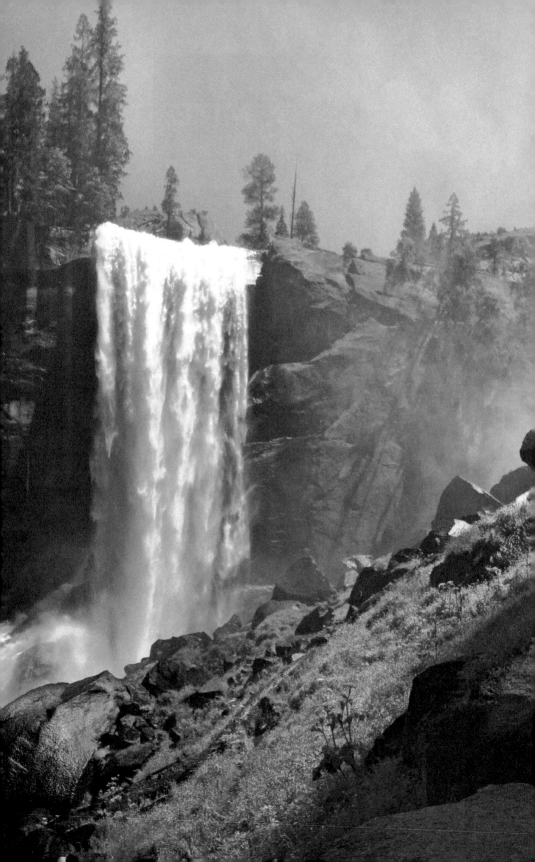

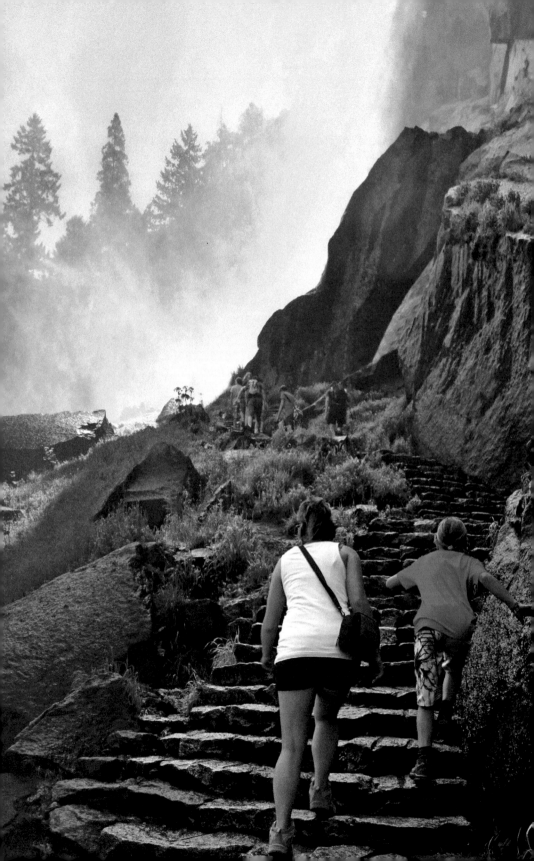

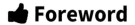 Foreword

By Bob Krist

A GREAT TRAVEL photograph, like a great news photograph, requires you to be in the right place at the right time to capture that special moment. Professional photographers have a short-hand phrase for this: "F8 and be there."

There are countless books that can help you with photographic technique, the "F8" portion of that equation. But until now, there's been little help for the other, more critical portion of that equation, the "be there" part.

To find the right spot, you had to expend lots of time and shoe leather to research the area, walk around, track down every potential viewpoint, see what works, and essentially re-invent the wheel.

In my career as a professional travel photographer, well over half my time on location is spent seeking out the good angles. Andrew Hudson's PhotoSecrets does all that legwork for you, so you can spend your time photographing instead of wandering about. It's like having a professional location scout in your camera bag. I wish I had one of these books for every city I photograph on assignment.

PhotoSecrets can help you capture the most beautiful sights with a minimum of hassle and a maximum of enjoyment. So grab your camera, find your favorite PhotoSecrets spots, and "be there!"

Bob Krist has photographed assignments for *National Geographic, National Geographic Traveler, Travel/Holiday, Smithsonian,* and *Islands.* He won "Travel photographer of the Year" from the Society of American Travel Writers in 1994, 2007, and 2008 and today shoots video as a Sony Artisan Of Imagery.

For *National Geographic,* Bob has led round-the-world tours and a traveling lecture series. His book *In Tuscany* with Frances Mayes spent a month on *The New York Times'* bestseller list and his how-to book *Spirit of Place* was hailed by *American Photographer* magazine as "the best book about travel photography."

After training at the American Conservatory Theater, Bob was a theater actor in Europe and a newspaper photographer in his native New Jersey. The parents of three sons, Bob and his wife Peggy live in New Hope, Pennsylvania.

☕ Contents

Gallery

Sunrise

Morning

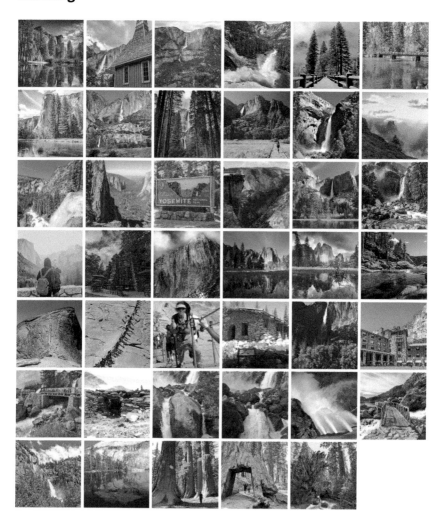

Afternoon

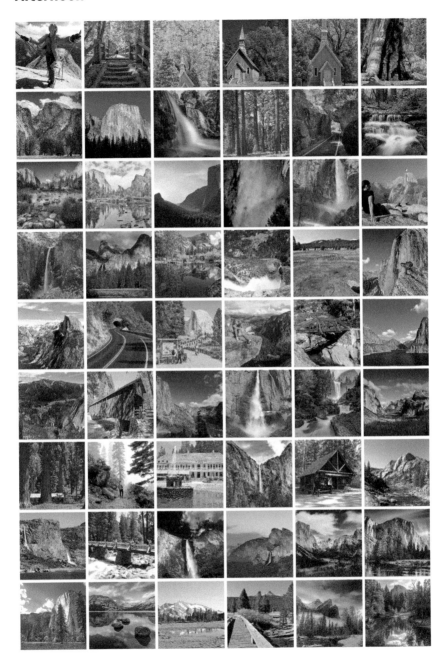

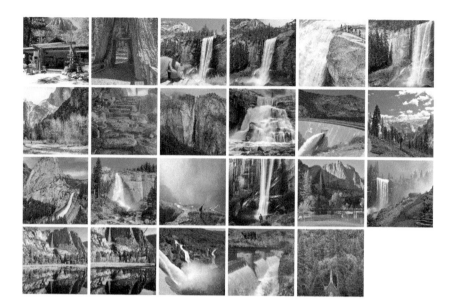

Sunset

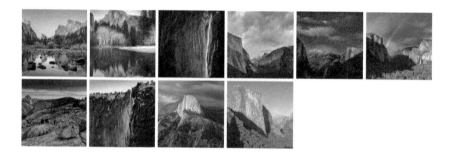

Dusk

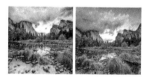

Indoors

◉ Yosemite

Yosemite National Park is a magnificent section of the Sierra Nevada mountains, in the east of California. Most of the photographic highlights are in the central 0.6% of the park, in the famed Yosemite Valley.

📍 1 West Valley / El Capitan

The **west portion of Yosemite Valley** is where all vehicle routes enter the valley. There are terrific overviews from Tunnel View and Gates of the Valley. To the north (the viewer's left) is El Capitan, a sheer granite cliff, and to the south (your right) is Bridalveil Fall.

📍 2 Center Valley / Yosemite Falls

The **center of Yosemite Valley** features Yosemite Falls, the highest combination waterfall in the park, dropping a total of 2,425 feet (740 m). There are views from the Merced River, across Cook's Meadow, and from the Lower Falls and Uppers Falls trails.

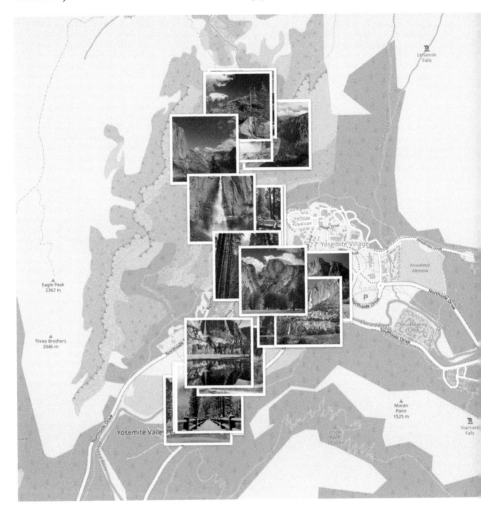

📍 3 North Valley / Yosemite Village

The **north section of the Valley** is home to Yosemite Village, with stores and lodging. Here, photographers can find the Ansel Adams Gallery, the Visitor Center, Yosemite Chapel, and the glorious Majestic Yosemite Hotel (formerly the Ahwahnee Hotel).

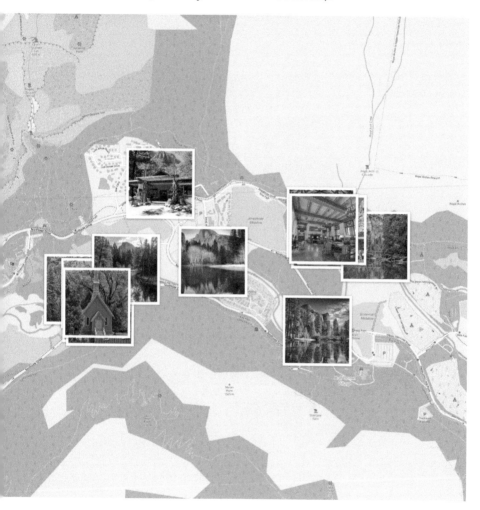

📍 4 East Valley / Half Dome

The **east part of the Valley** is dominated by the park's signature rock — Half Dome, a towering granite ridge with a sheer face. The adventurous can climb the Mist Trail to Vernal Fall and Nevada Fall, and even ascend Half Dome.

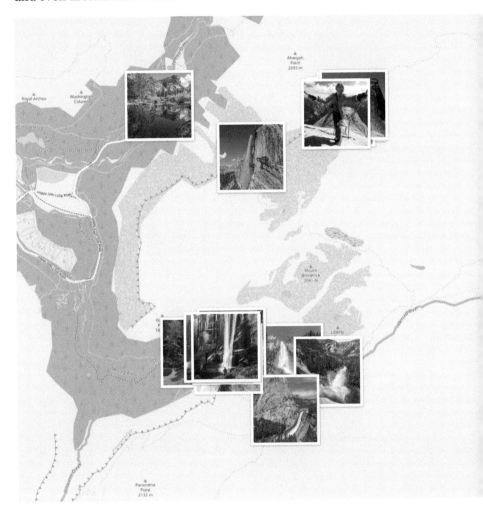

📍 5 South Valley / Glacier Point

The **south wall of Yosemite Valley** includes Glacier Point, with views of Half Dome and Yosemite Falls. Nearby is Taft Point and Illilouette Fall.

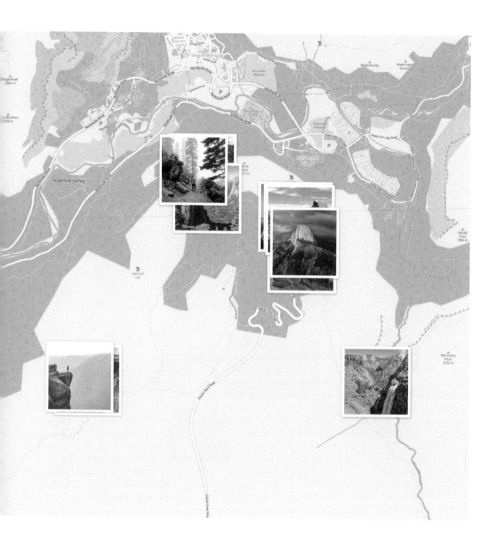

📍 6 West Park / Big Oak Flat

Yosemite Park's west side is where most people enter the park. The Big Oak Flat entrance on CA-120 leads to two groves of giant sequoia trees, while the Arch Rock entrance on CA-140 (El Portal Road) has an arch rock and winds along the Merced River.

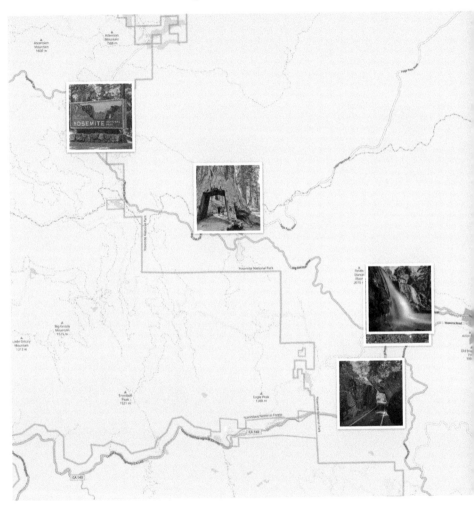

📍 7 South Park / Wawona

Yosemite Park's south side includes the town of Wawona with a covered bridge and an historic hotel, and the Mariposa Grove of giant sequoia trees. The Wawona Road is the Park's entrance from Southern California.

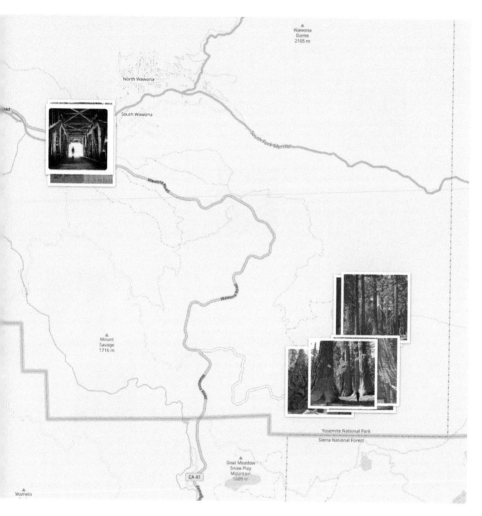

♥ 8 North Park / Hetch Hetchy

Yosemite Park's north side is harder to access. The glacial Hetch Hetchy Valley is similar to Yosemite Valley, with waterfalls and granite cliffs, but was dammed in the 1920s and is now a reservoir for San Francisco. There are trails up the Tuolumne River.

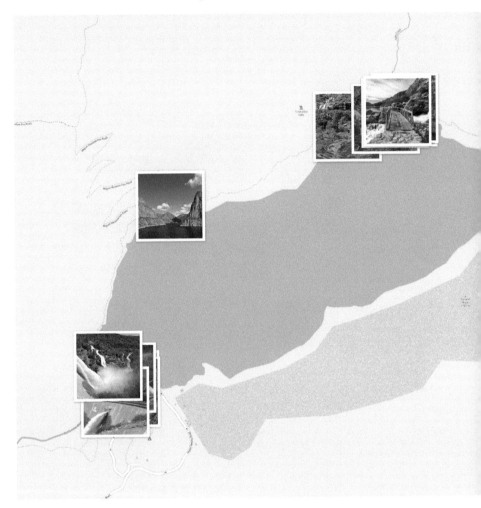

📍 9 East Park / Tioga Road

Yosemite Park's east side is traversed by Tioga Road, the only road east. Tuolumne Meadows has crystal-clear lakes and granite domes. Tioga Pass is the highest mountain pass in California and is closed in the winter season.

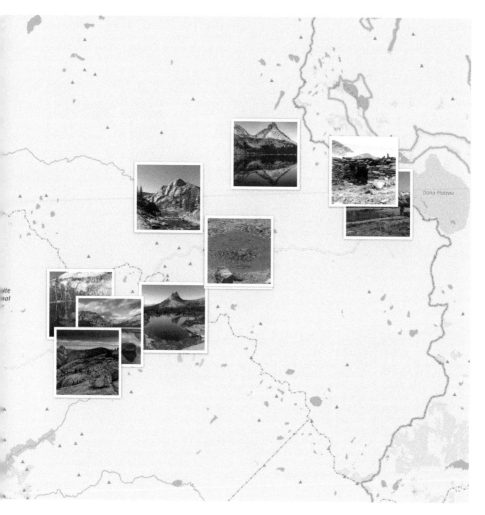

ⓘ Introduction

Yosemite National Park is one of nature's most photogenic locations. In the namesake valley, sheer granite walls are laced with a dozen waterfalls — some of the world's tallest — and tower over verdant meadows and a meandering river. It's justly known as "The Incomparable Valley." Wherever you turn seems to be a view made famous by legendary photographer, Ansel Adams.

Elsewhere in the park are giant sequoia groves, crystal-clear lakes, mountains and glaciers.

Indigenous inhabitants called the valley "Ahwahnee" ("big mouth"). When the Mariposa Battalion entered in 1851, the native tribe was known by rival Miwoks as *yohhe'meti* (meaning "they are killers"), which the company physician, Dr. Lafayette Bunnell, wrote in an article and book as "Yo-semite."

The glorious wilderness was central to the development of the national park idea. Galen Clark settled in the area around 1857 and, with others, lobbied to protect Yosemite Valley from development, ultimately leading to President Abraham Lincoln's signing the Yosemite Grant in 1864. John Muir led a successful movement to have Congress establish a larger national park by 1890, one which encompassed the valley and its surrounding mountains and forests, paving the way for the National Park System. Today, over four million people annually visit Yosemite National Park.

About 10 million years ago, the Sierra Nevada was uplifted and then tilted to form its relatively gentle western slopes and the more dramatic eastern slopes. The uplift increased the steepness of stream and river beds, resulting in the formation of deep, narrow canyons. About one million years ago, snow and ice accumulated, forming glaciers at the higher alpine meadows that moved down the river valleys. Ice thickness in Yosemite Valley may have reached 4,000 feet (1,200 m) during the early glacial episode. The downslope movement of the ice masses cut and sculpted the U-shaped valley that attracts so many visitors to its scenic vistas today.

"No temple made with hands can compare with Yosemite. Every rock in its walls seems to glow with life."
— John Muir.

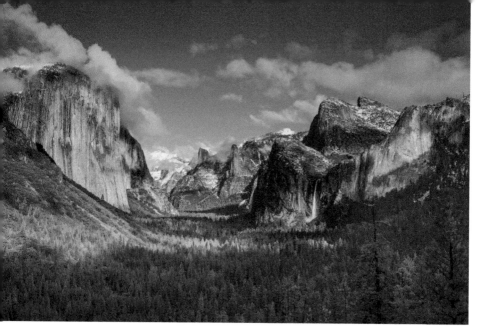

Tunnel View is the classic picture of Yosemite Valley. Looking east up the valley, you can see three signature sights — El Capitan, Half Dome and Bridalveil Fall. From here, Ansel Adams photographed one of his most famous images, *Clearing Winter Storm* in 1935. I'm sure you can do an equally splendid shot!.

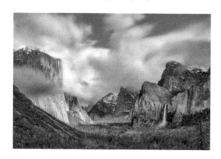
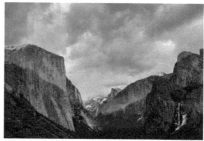

✉ **Addr:**	Wawona Road, Yosemite Valley CA 95389	♀ **Where:**	37.71576 -119.67718	
◑ **When:**	Afternoon	👁 **Look:**	East-northeast	
📷 **Lens:**	28mm	W **Wik:**	Tunnel_View	

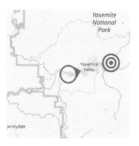
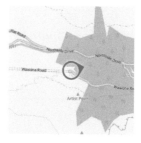
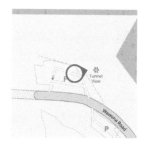

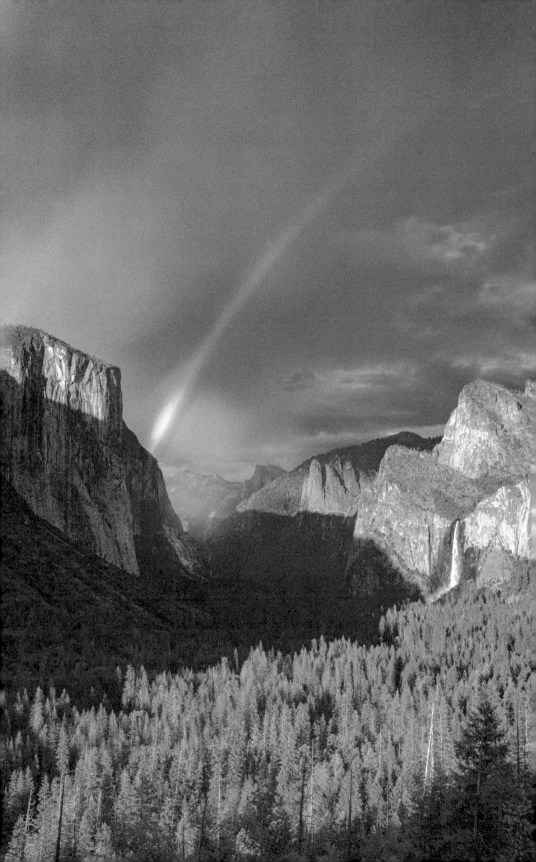

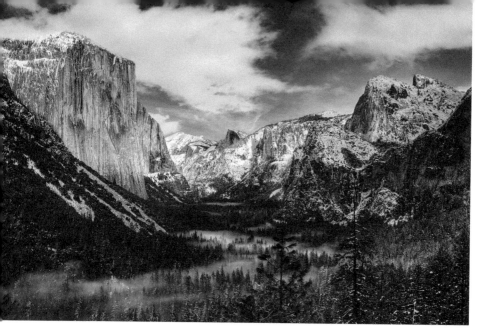

Winter provides a dusting of snow while spring sees Bridalveil Fall at its fullest.

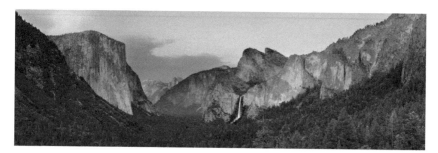

In the late afternoon, the conveniently west-facing rock faces are lit by golden light.

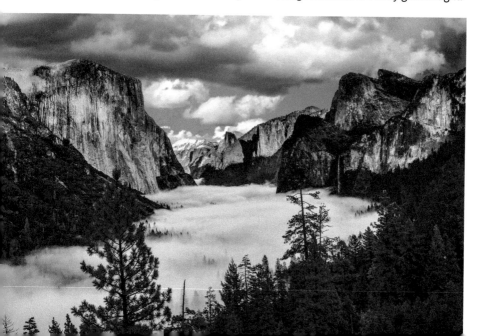

1 West Valley / El Capitan > Wawona Road > Tunnel View > classic view

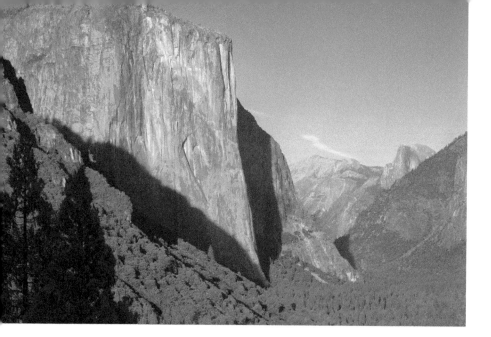

El Capitan from Tunnel View is a spectacular sight, with its full
face reflecting the golden sunlight of late afternoon. The almost sheer
granite rock is about 3,000 feet (914 m) from base to summit and a
similar width near the top.

The Apple Mac operating system OS X
10.11 is named El Capitan, and includes a
screensaver image of the cliff from Tunnel
View.

✉ **Addr:**	Wawona Road, Yosemite Valley CA 95389	♀ **Where:**	37.715598 -119.676940
◑ **When:**	Sunset	◉ **Look:**	East-northeast
📷 **Lens:**	85mm	W **Wik:**	El_Capitan

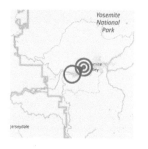

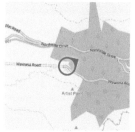

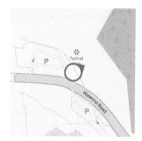

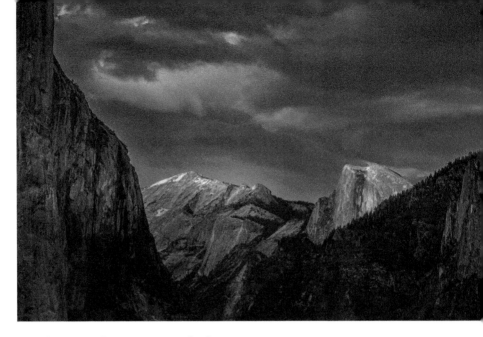

Half Dome from Tunnel View is another classic shot. You'll

need a longer lens — 135mm for a 35mm camera, or the equivalent for cameras with different sensor sizes — and a tripod for sharp image (or you can rest your camera on the wall).

Half Dome is over eight miles (13 km) away at the other end of Yosemite Valley. The rock ridge to the left is Clouds Rest, the highest point in Yosemite Valley at 9,930 feet (3,027 m). These two peaks are the last to reflect the light of the setting sun, so this makes a great last shot of the day.

✉ **Addr:**	Wawona Road, Yosemite Valley CA 95389	♀ **Where:**	37.71576 -119.67718
◑ **When:**	Sunset	◉ **Look:**	East-northeast
◎ **Lens:**	135mm	Ⓦ **Wik:**	Tunnel_View

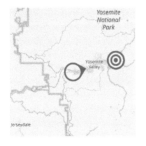

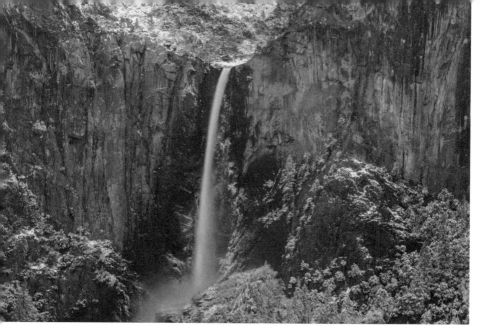

Bridalveil Fall from Tunnel View is an incredible view, like scenery from *The Land That Time Forgot.*

The waterfall is 617 ft (188 m) in height and, due to a large and absorbant watershed, flows year round.

This is the second rock face to catch the golden hour afternoon light, after El Capitan and before Half Dome.

✉ **Addr:**	Wawona Road, Yosemite Valley CA 95389	♀ **Where:**	37.715598 -119.676822
◑ **When:**	Afternoon	👁 **Look:**	East
📷 **Lens:**	150mm	W **Wik:**	Bridalveil_Fall

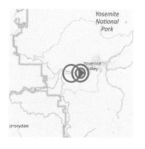

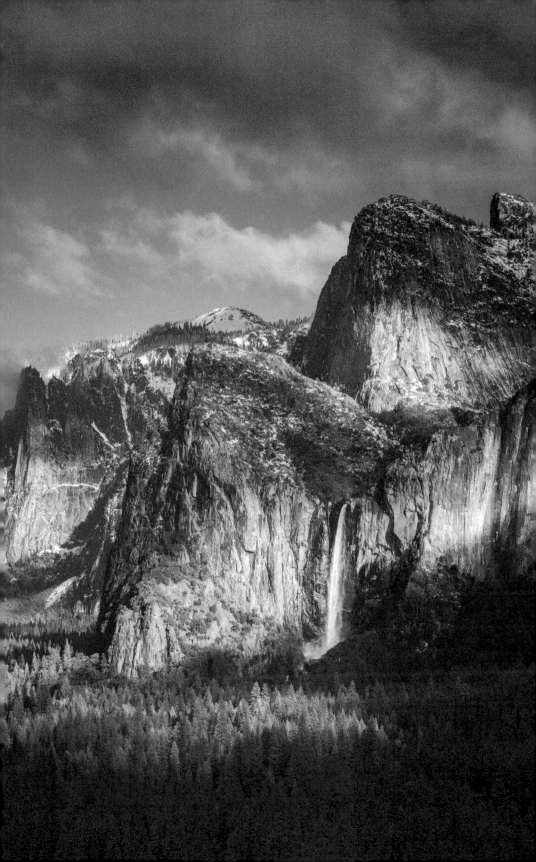

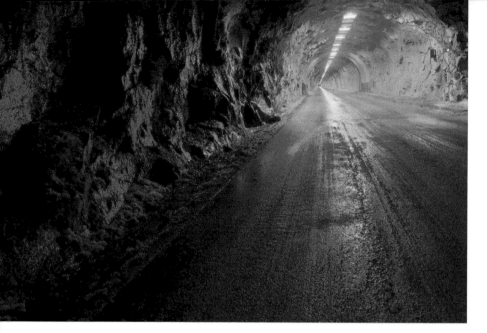

The **Wawona Tunnel** is a highway tunnel that gives Tunnel View its name. Completed in 1933, the tunnel was bored through solid granite bedrock and is the longest highway tunnel in California, at 4,233 feet (1,290 m) long. Since this is 4/5 of a mile, the tunnel is also known as "Whiskey Tunnel" (spirit bottles were 4/5 of a quart).

The view above (with ragged rock) is from the east side by Tunnel View (which is built on landfill from the tunnel). The following view (with smooth concrete) is from the west side, with the camera resting on the tarmac. Watch for traffic!.

✉ **Addr:**	Wawona Road, Yosemite Valley CA 95389	♀ **Where:**	37.715374 -119.677559
◑ **When:**	Anytime	👁 **Look:**	West
📷 **Lens:**	28mm	W **Wik:**	Wawona_Tunnel

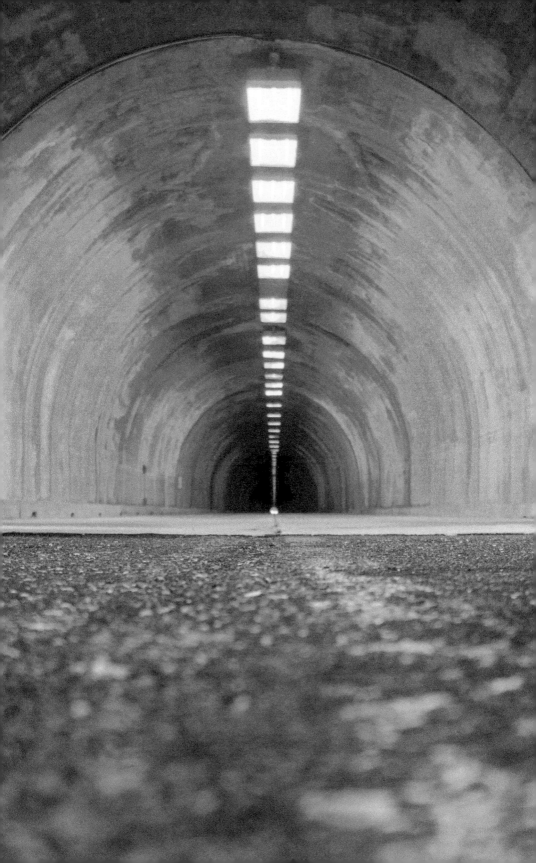

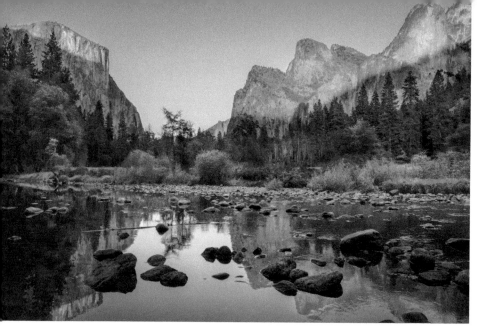

Valley View has a magnificent view similar to Tunnel View, but with water in the foreground and far less visitors. Also known as Gates of the Valley, this is a tranquil spot to watch the last rays of the setting sun move from left to right, as if being covered by a slowly drawn curtain.

The Merced River here flows across the shot, forming a unifying and reflective foreground. Crouch low to bring the water almost to eye level. By using a small aperture (such as f/22) you can get the close foreground and the far background in focus, a wide depth-of-field.

"We finally emerged at Valley View — the splendor of Yosemite burst upon us and it was glorious. ... A new era began for me."
— Ansel Adams, of his first visit in 1916 at age 12.

✉ **Addr:**	Northside Drive, Yosemite Valley CA 95389	♀ **Where:**	37.717092 -119.661911
When:	Sunset	👁 **Look:**	East-northeast
📷 **Lens:**	28mm	↔ **Far:**	2.21 km (1.37 miles)

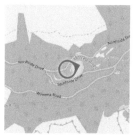

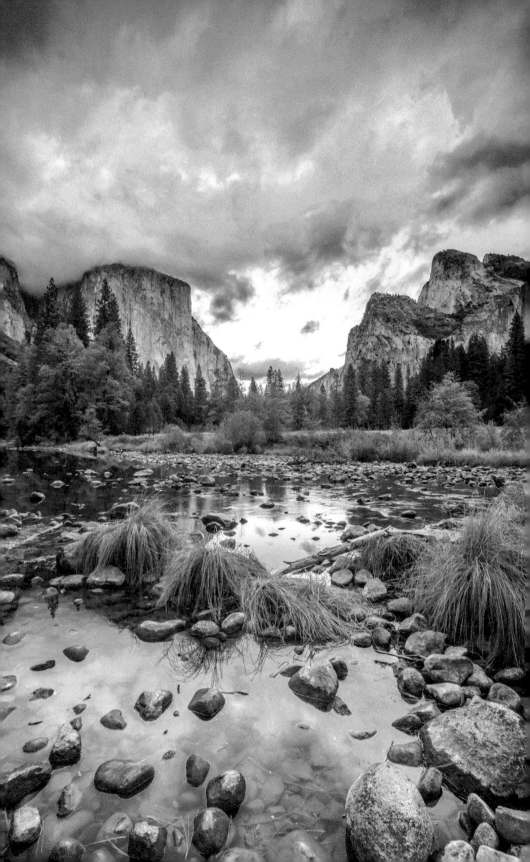

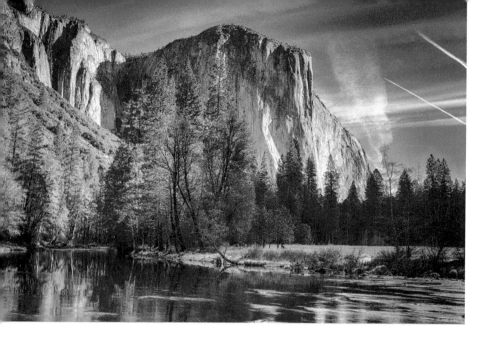

El Capitan from Valley View is such a classic picture that it was depicted on a 2010 "America the Beautiful" United States quarter dollar coin.

Valley View has a small parking area on Northside Drive (just east of the junction with Southside Drive) which is feet from the river bank.

El Capitan is photogenic throughout the day. In the morning, the sunlight catches the rock's edge and companion faces — providing depth to your photograph — and backlights the meadow grass. In the afternoon, the entire view is lit by sun, and you can watch the golden light ascend the rock face as the sun sets.

✉ **Addr:**	Northside Drive, Yosemite Valley CA 95389	♥ **Where:**	37.717118 -119.661836	
◑ **When:**	Afternoon	👁 **Look:**	Northeast	
📷 **Lens:**	50mm	W **Wik:**	El_Capitan	

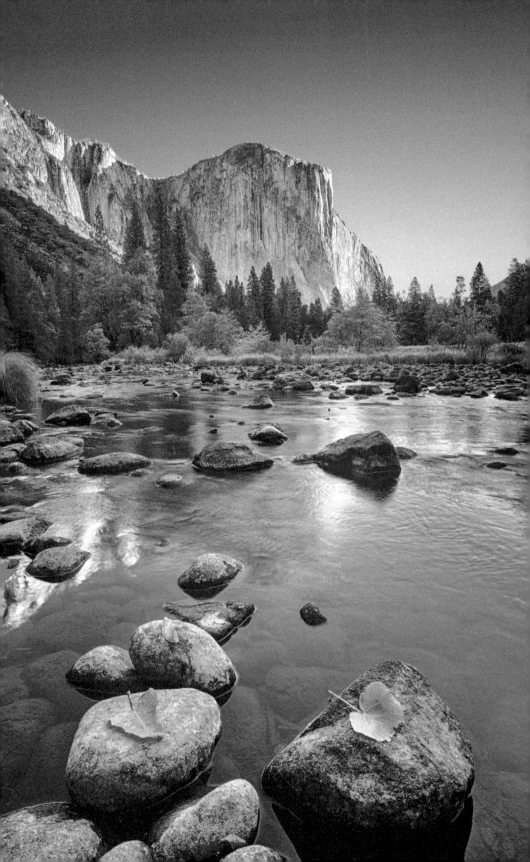

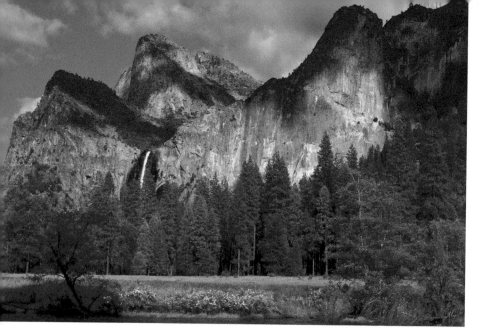

Bridalveil Fall from Valley View shows the waterfall between Cathedral Rocks (left and behind) and Leaning Tower (right). Tall conifers and a verdant meadow help frame the shot and provide scale.

Valley View demonstrates the value of "working the shot" — trying different angles and cropping at one location. You can stand in one place and take a variety of pictures. Spending additional time at a spot is one of the best ways to improve and develop your photography. Explore the subject and see what appeals to you — perhaps the light on the trees or a detail in the view — then crop and hone in on your unique image.

✉ **Addr:**	Northside Drive, Yosemite Valley CA 95389	♀ **Where:**	37.717096 -119.661854
☽ **When:**	Afternoon	👁 **Look:**	East
📷 **Lens:**	50mm	W **Wik:**	Bridalveil_Fall

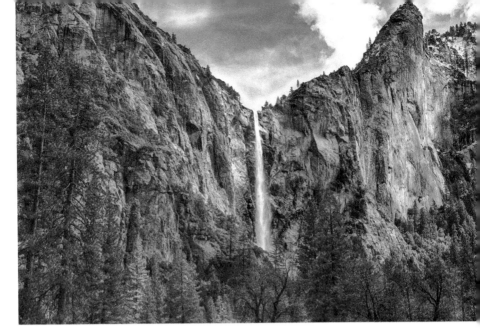

Bridalveil Fall is considered to be the most beautiful of Yosemite's waterfalls. The wind gently sways the whispy waters back and forth as it drops 617 feet (188 m). This motion is a delight to watch and is called the "Pohono effect" — the Ahwahneechee Native American word for "Spirit of the Puffing Wind."

A 10-minute trail winds up Bridalveil Creek to a viewing platform. The mist is pleasantly cooling in the summer but you may need waterproof clothing in the spring.

✉ **Addr:**	Southside Drive, Yosemite Valley CA 95389	♀ **Where:**	37.7220679 -119.6499092
When:	Afternoon	👁 **Look:**	South-southeast
📷 **Lens:**	35mm	W **Wik:**	Bridalveil_Fall

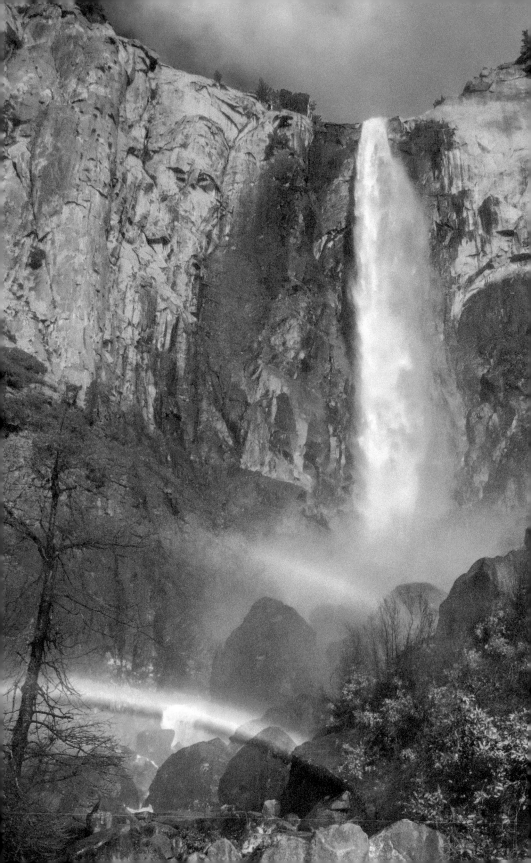

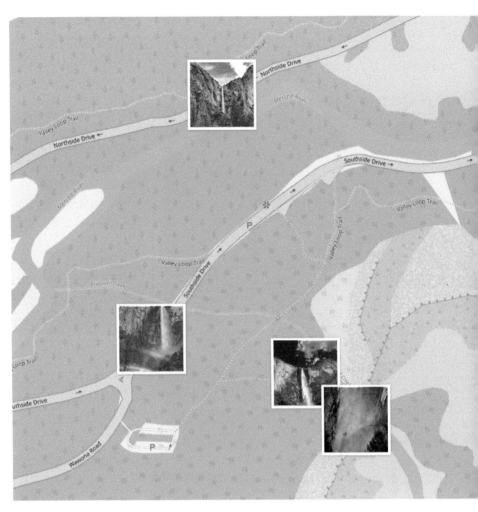

 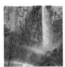

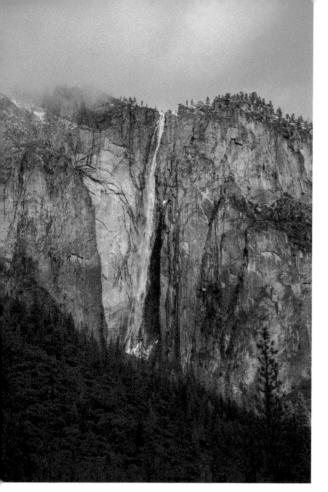

Ribbon Fall from Bridalveil Fall Trailhead is a view

from Southside Drive of the north side waterfall. Ribbon Fall is to the west of El Capitan and is the longest single-drop waterfall in North America, with a height of 1,612 feet (491 m).

Ribbon Fall only flows in the spring as it is fed by melting snow rather than a large watershed like Bridaleveil Fall.

✉ **Addr:**	Southside Drive, Yosemite Valley CA 95389	♀ **Where:**	37.7205493 -119.6484244
☾ **When:**	Afternoon	👁 **Look:**	North
📷 **Lens:**	85mm	Ｗ **Wik:**	Ribbon_Fall

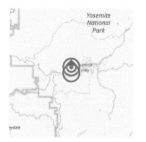

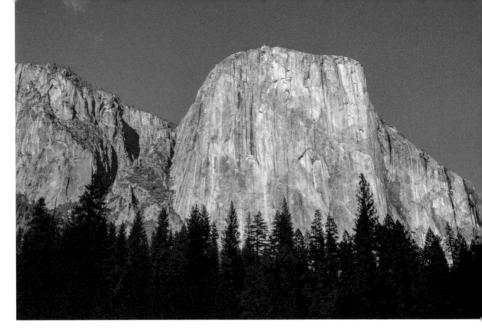

El Capitan from Bridalveil Fall Trailhead is a view with a

carpet of conifers in the foreground.

There are three trailheads to Bridalveil Fall. The main trail starts at a parking area off Wawona Road. About 1,800 feet (540 m) northeast on Southside Drive are two other trailheads with on-street parking, from which this shot and the one of Ribbon Fall are taken.

✉ **Addr:**	Southside Drive, Yosemite Valley CA 95389	♀ **Where:**	37.7206546 -119.6482361	
◑ **When:**	Afternoon	◉ **Look:**	Northeast	
📷 **Lens:**	28mm	W **Wik:**	El_Capitan	

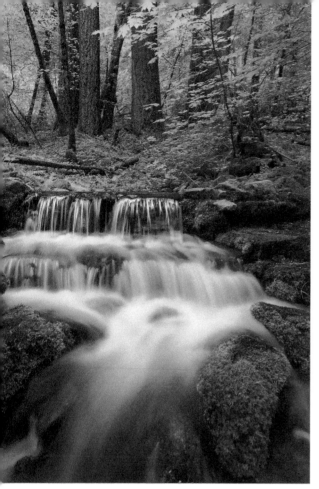

Fern Spring emanates from the ground into a beautiful little pool, with a two-step waterfall and mossy rocks in the foreground and a leafy forest in the background.

The natural spring is a real "photo secret" since most people drive right past it without knowing this photographic gem is there.

Fern Spring is located just off Southside Drive (there is a small pullout and sign), about 600 feet (180 m) south of Pohono Bridge.

To capture a fairytale image, crouch low with your camera near the water, and use a slow shutter (such as 1/8s) to make the water romantic and blurred.

✉ **Addr:**	Southside Drive, Yosemite Valley CA 95389	♀ **Where:**	37.715186 -119.665381
◑ **When:**	Afternoon	👁 **Look:**	Southeast
📷 **Lens:**	35mm	↔ **Far:**	14 m (46 feet)

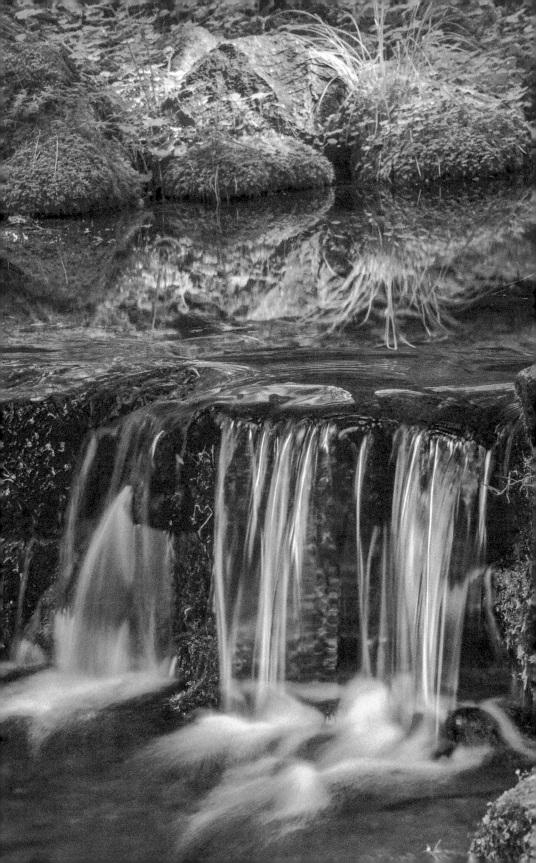

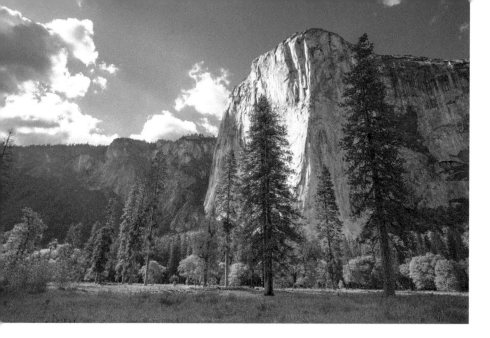

El Capitan from El Capitan Meadow is a triangular, face-on view of the granite monolith with a meadow and river in the foreground.

From El Capitan Drive/Northside Drive just west of El Capitan Bridge is a trail which loops through the meadow and back to the road. In the morning, the light is on the right (east) wall, and in the afternoon the light is on the left (west) wall — your choice!.

Shots like this are tricky because the subject is in the background. Look for an interesting foreground (grass, trees, the river, a person in a red jacket) to add some depth and scale to your picture.

✉ **Addr:**	Northside Drive, Yosemite Valley CA 95389	♀ **Where:**	37.7214615 -119.6340073	
◑ **When:**	Anytime	◉ **Look:**	North	
📷 **Lens:**	18mm	W **Wik:**	El_Capitan	

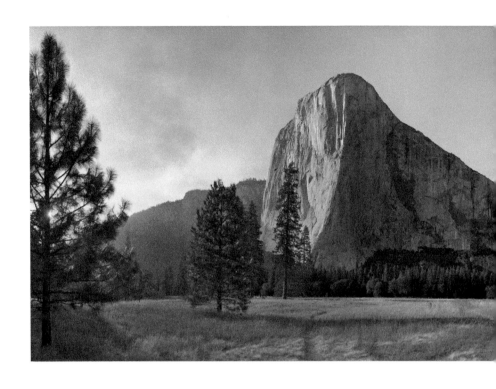

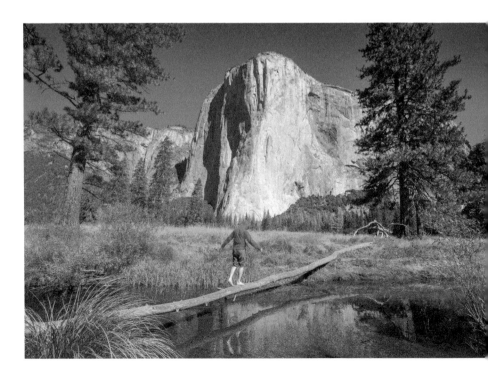

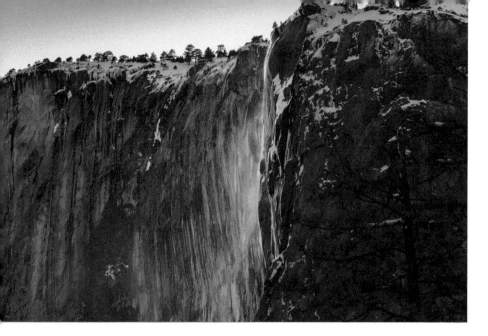

Horsetail Fall "Firefall" from Northside Drive is a

hallowed shot for photographers. In a good year, for a few minutes in a few days, a sliver of sunlight strikes this gossamer waterfall perfectly, creating a miracle of nature and photography.

Horsetail Fall is located on the east side of El Capitan and is seasonal, fed by melting snow and flowing briefly in snowy years. If it is flowing around February 21 and the weather conditions are just right, the setting sun illuminates the water, making it glow orange and red. This natural phenomenon is called the "Firefall" since it looks like an old Yosemite attraction when fire embers were pushed off Glacier Point.

This view is taken from the "Galen Rowell shot spot" — a small clearing close to the picnic area on Northside Drive east of El Capitan.

✉ **Addr:**	Northside Drive, Yosemite Valley CA 95389	♀ **Where:**	37.728383 -119.620664
☽ **When:**	Sunset	👁 **Look:**	West
📷 **Lens:**	70mm	Ⓦ **Wik:**	Horsetail_Fall_(Yosemite)

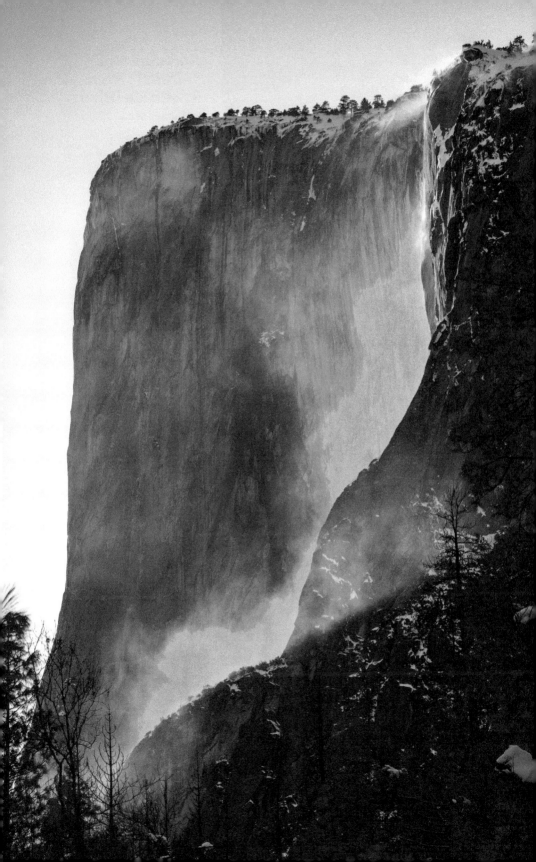

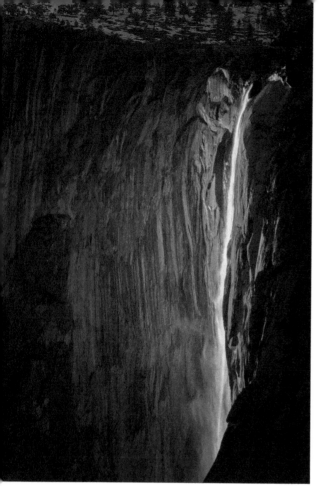

Horsetail Fall "Firefall" from Southside Drive is

a cleaner view. This is taken from the south side of the Merced River, near the parking area at Cathedral Beach.

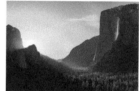

✉ **Addr:**	Southside Drive, Yosemite Valley CA 95389	♀ **Where:**	37.723402 -119.621539
◑ **When:**	Sunset	👁 **Look:**	Northwest
📷 **Lens:**	300mm	W **Wik:**	Horsetail_Fall_(Yosemite)

How to photograph the "Firefall".

Climber and adventure photographer Galen Rowell made the first known color photo of the Firefall in 1973, called *Last Light on Horsetail Fall*. Since then, an increasing number of photographers have been drawn to this "bucket list" shot, partly because of how hard and rare it is to achieve. Here are some tips.

When: The stars align (or at least the sun and the waterfall align) for about two weeks in mid-to-late-February. Perfect light occurs just before sunset, around 5:15 to 5:45 pm. Golden sunlight is reflected off the granite walls and backlights through the water and mist. However, the effect does not always occur. There are two main factors: water and weather.

1. **Water**. There must be enough snow before late February for snowmelt to feed the waterfall. No snow, no waterfall. And there needs to be just the right amount of melting snow. Too much water and it blocks the sunset from hitting the falls.

2. **Weather**. You need clear skies. The sunlight comes from the horizon at sunset, and any clouds will block the light and Horsetail Fall will not be illuminated. Even some haze or minor cloudiness can greatly diminish or eliminate the effect. The weather in winter is variable so your only choice here is to risk it and be lucky. A little wind is helpful to stir up the mist and increase the golden area.

Planning is necessary for this shot as you are not the only photographer in the park. To ensure safety and access, driving and parking is highly restricted, so check with the National Park Service for the latest arrangements before arriving. You may have to park several miles from the viewpoint.

You'll want to claim your spot early in the day, then wait for hours, so bring food, water, a hat, gloves, boots, reading material, a chair, and a headlamp or flashlight.

Bring a sturdy tripod as the shutter speed will be slow, around 1/0th second or less. Using a cable release or a remote shutter control removes the camera shake of pressing the shutter release yourself.

For the classic shot, use a 300mm lens for a camera with a 35mm "full-frame" sensor, or the equivalent for other cameras (e.g. 200mm for a 2/3-frame sensor).

Here are some websites for more information:.
nps.gov/yose/planyourvisit/horsetailfall.htm.
travelcaffeine.com/yosemite-firefall-photography-tips.

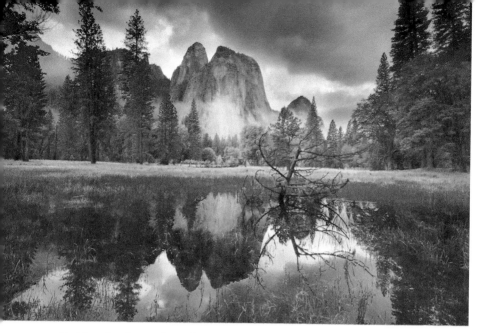

Cathedral Rocks Vista looks west across the Merced River to the east side of Cathedral Rocks. This is other side of the rock formation that, from Tunnel View, is behind Bridalveil Fall.

The Merced River snakes south-to-north across the shot, providing a full-width reflecting pool for your picture.

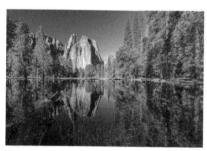

✉ **Addr:**	Northside Drive, Yosemite Village CA 95389	📍 **Where:**	37.7254881 -119.6268854	
◑ **When:**	Morning	👁 **Look:**	Southwest	
📷 **Lens:**	20mm	W **Wik:**	Middle_Cathedral_Rock	

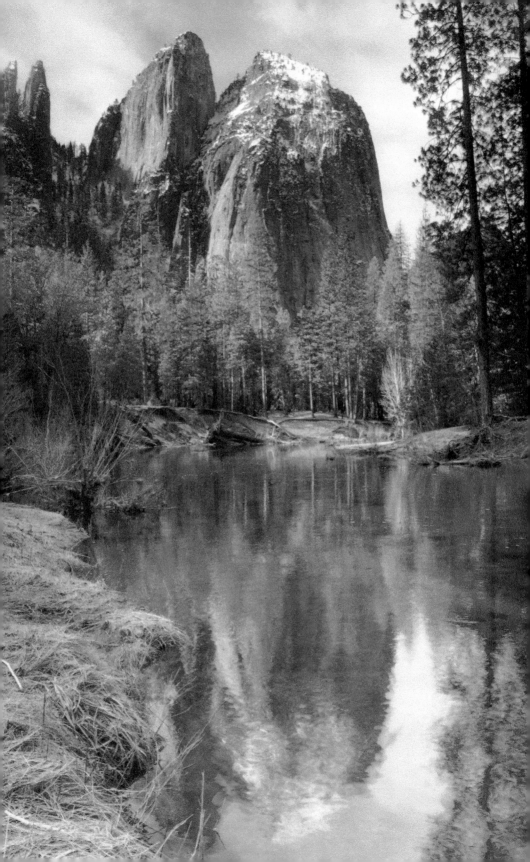

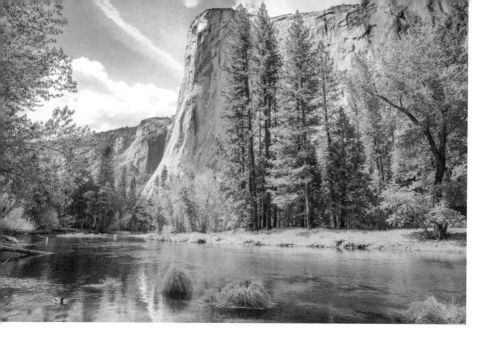

El Capitan from Cathedral Beach shows the monolith's profile edge, known as *The Nose*. The Nose Route is often called the most famous rock climbing route in North America and, in 2018, Tommy Caldwell and Alex Honnold climbed the full 2,900 feet (880 m) in under two hours.

El Capitan is Spanish for "the captain" or "the chief" as a loose translation by the Maripose Battalion in 1851 of the local Native American name for the cliff, "To-to-kon oo-lah" or "To-tock-ah-noo-lah."

The granite face is over 100 million years old. Along with most of the other rock formations of Yosemite Valley, El Capitan was carved by glacial action, mostly about a million years ago.

✉ **Addr:**	Southside Drive, Yosemite Valley CA 95389	📍 **Where:**	37.722978 -119.623529
🕐 **When:**	Morning	👁 **Look:**	North-northwest
📷 **Lens:**	35mm	W **Wik:**	El_Capitan

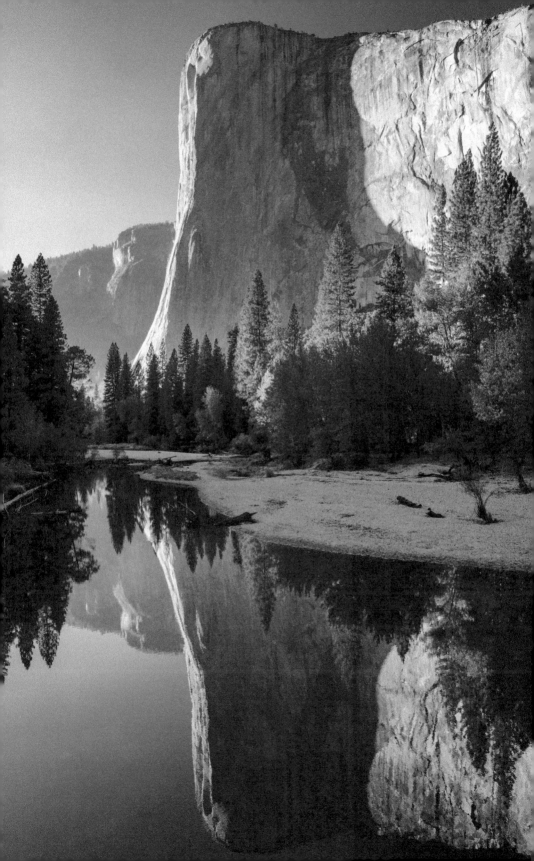

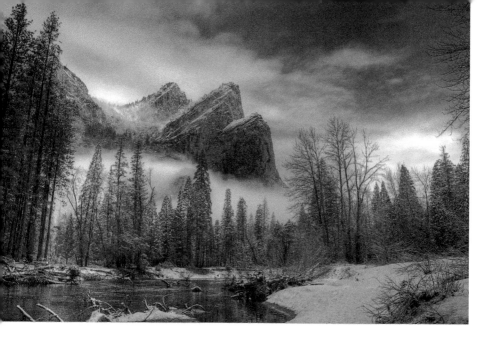

The **Three Brothers from Cathedral Beach** is another seemingly primordial view. Located just east of El Capitan, the formation consists of Eagle Peak (the uppermost "brother"), with Middle Brother and Lower Brother.

The rocks were named in 1851 when the Mariposa Battalion captured the three sons of Chief Tenaya near the base. The native American name is more romantic — "Kom-po-pai-zes", or sometimes "Pompomposus", meaning "mountains with heads like frogs when ready to leap."

✉ **Addr:**	Southside Drive, Yosemite Valley CA 95389	♀ **Where:**	37.7232001 -119.6221828
☽ **When:**	Afternoon	👁 **Look:**	North-northeast
📷 **Lens:**	50mm	W **Wik:**	Three_Brothers_(Yosemite)

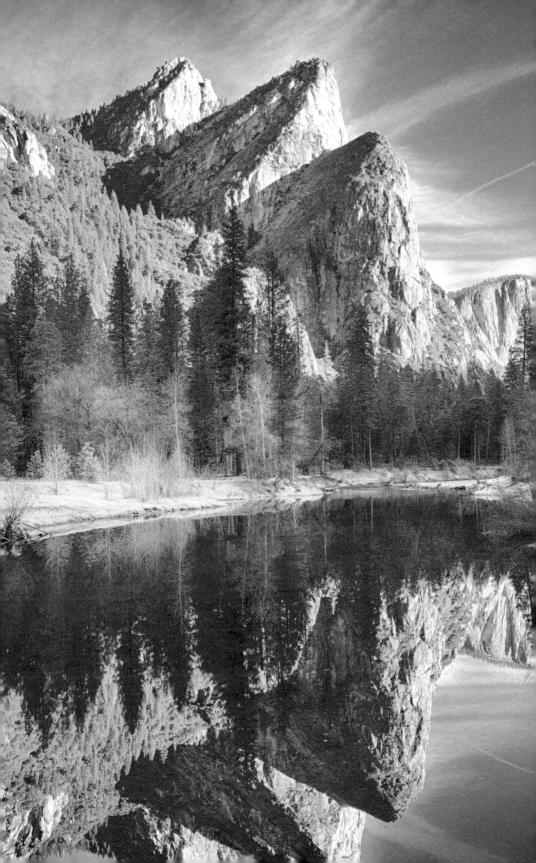

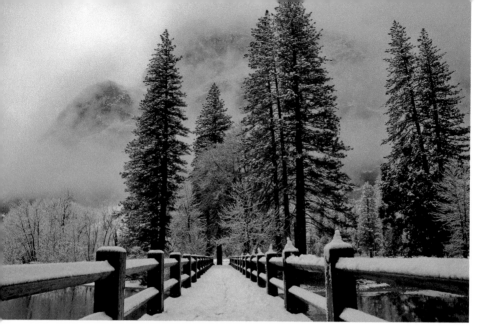

Swinging Bridge is the first pedestrian bridge from the west.

Bridges make excellent photography subjects as the long horizontal lines lead the viewer's eye from the close foreground to the deep background, providing a key element for a flat, two-dimensional image — the illusion of depth.

In the summer, this area has a beach-like atmosphere, with banks of sand on either side and swimmers in the river.

From — and with — Swinging Bridge are excellent views of the next amazing sight, Yosemite Falls.

✉ **Addr:**	Southside Drive, Yosemite Valley CA 95389	♀ **Where:**	37.737002 -119.600578
☾ **When:**	Afternoon	👁 **Look:**	East-southeast
📷 **Lens:**	28mm	W **Wik:**	Swinging_Bridge

Swinging

Merced River

→ Southside

 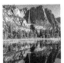 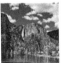

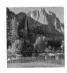

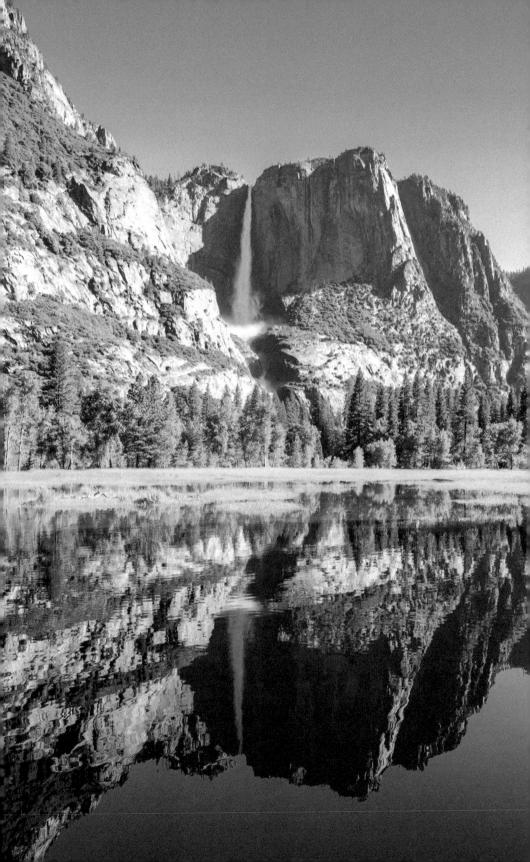

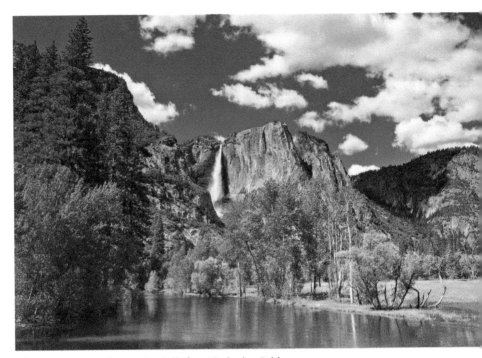

Above: The view of Yosemite Falls from Swinging Bridge.
Below: From the southwest toward Sentinel Beach you can photograph Yosemite Falls with Swinging Bridge in the foreground, and hopefully a boater for scale.

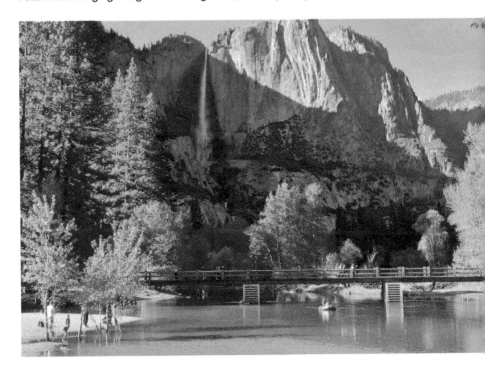

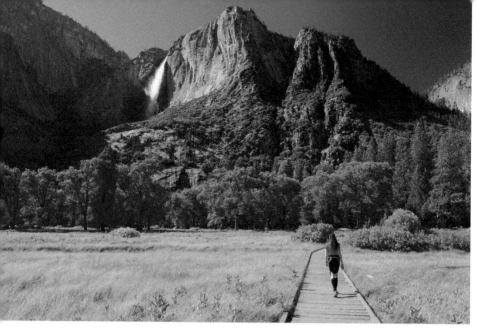

Cook's Meadow has lovely pastoral views of Yosemite Falls. You can include a hiker on the boardwalk for scale, or the Merced River for that ever-important foreground. As a scenic photographer, you are always in search of a foreground, to add depth and scale to your pictures.

Located in the center of Yosemite Valley, Cook's Meadow has the easiest scenic trail in the park, an easy and flat one-mile (1.6 km) loop with views of Yosemite Falls, Half Dome, Glacier Point, and Sentinel Rock. You can walk to the trail from the Visitor Center, and from the Yosemite Falls Trailhead parking area.

✉ **Addr:**	Northside Drive, Yosemite Valley CA 95389	♀ **Where:**	37.745057 -119.5894626
◑ **When:**	Morning	◉ **Look:**	North-northwest
◎ **Lens:**	28mm	W **Wik:**	Yosemite_Falls

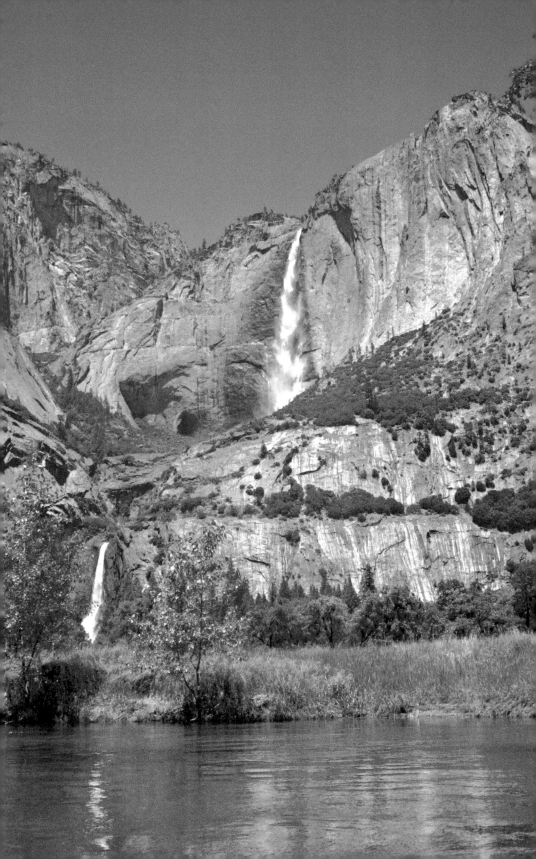

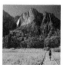

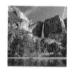

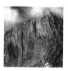

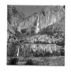

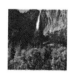

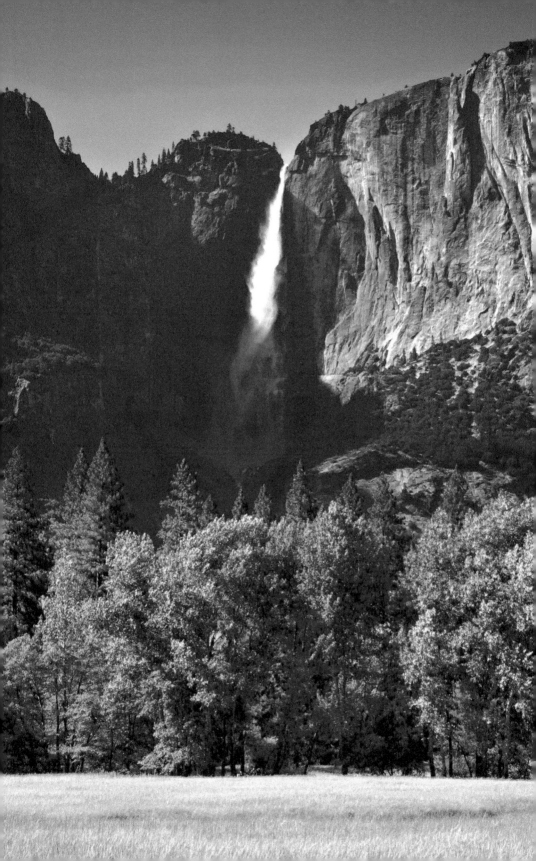

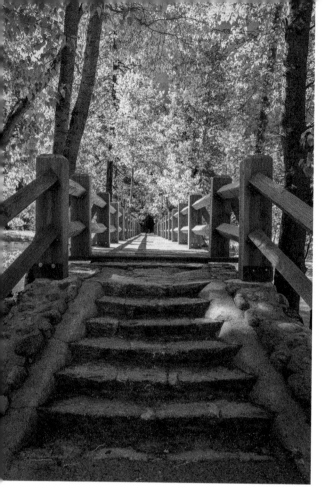

Cook's Meadow Bridge

Cook's Meadow Bridge is the second pedestrian bridge from the west. The stone steps on the northwest side make a good foreground, leading the viewer's eye to the bridge rails which recede into the background, creating depth in the center of the shot. Or you can just cross to the other side.

✉ **Addr:**	Southside Drive, Yosemite Valley CA 95389	📍 **Where:**	37.7433 -119.593244
❓ **What:**	Pedestrian bridge	🌙 **When:**	Afternoon
👁 **Look:**	Southeast	↔ **Far:**	30 m (110 feet)

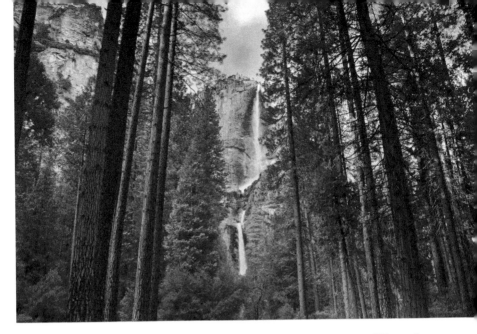

Yosemite Falls from the Lower Yosemite Fall Trailhead

is a beautifully framed shot, with tall trees either side of the double waterfall beyond. Notice how a horizontal format emphasizes the trees while a vertical format emphasizes the path and waterfall.

A paved flat path makes for an easy 1/4 mile (440 m) walk to a viewpoint and bridge close to the base on Lower Yosemite Fall.

Yosemite Falls is the highest waterfall in Yosemite National Park, dropping a total of 2,425 feet (739 m) from the top of the upper fall to the base of the lower fall. Spring is the best time to photograph; in all but the wettest years, the falls cease flowing altogether in late summer or fall.

✉ **Addr:**	Northside Drive, Yosemite Valley CA 95389	♀ **Where:**	37.746596 -119.596217
☾ **When:**	Morning	◉ **Look:**	North
◎ **Lens:**	28mm	W **Wik:**	Yosemite_Falls

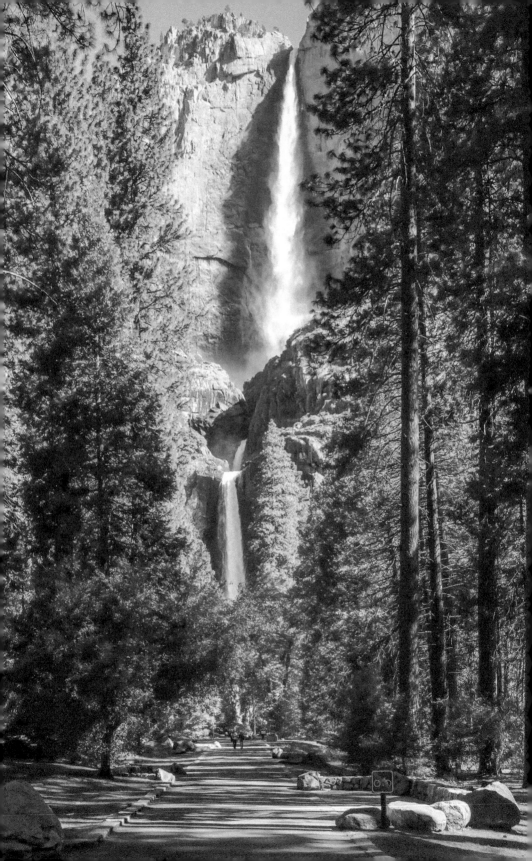

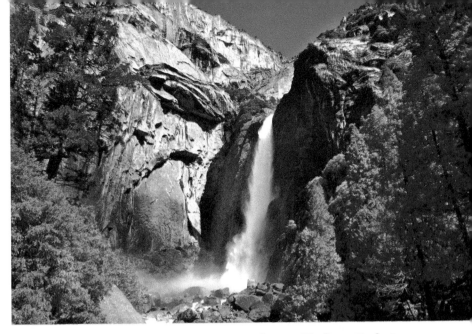

Yosemite Falls from Lower Yosemite Fall Vista Point is

the nearest you can safely get to the base of the valley's namesake waterfall. There is a paved viewing area on the west bank of the creek, from where you can take the photograph above. You can look back for a view of the pedestrian bridge across the creek (below).

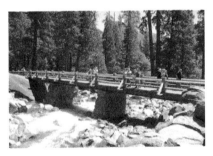

From the bridge (next page), you can get a bird's-eye view over Yosemite Creek, with people at Vista Point on the left to show the amazing scale of the scenery.

✉ **Addr:**	Northside Drive, Yosemite Valley CA 95389	♀ **Where:**	37.749973 -119.5960058
☽ **When:**	Morning	👁 **Look:**	North-northwest
📷 **Lens:**	28mm	W **Wik:**	Yosemite_Falls

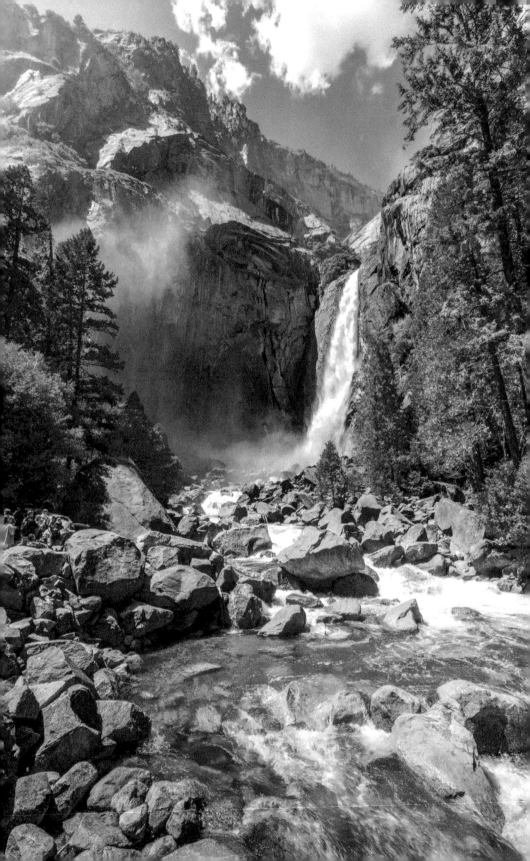

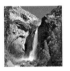 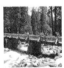

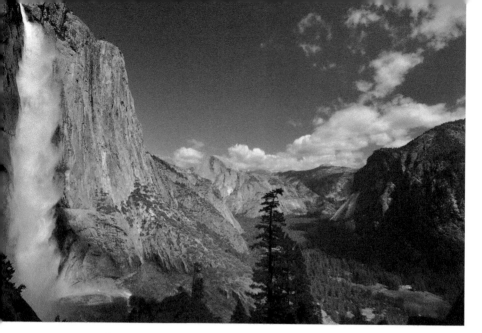

Yosemite Falls Trail

Yosemite Falls Trail is a steep, strenuous but rewarding 6–8 hour round-trip hike to the top of Yosemite Falls, North America's tallest waterfall. One of Yosemite's oldest historic trails (built 1873 to 1877), the path rises 2,425 feet (739 m) above the Valley floor.

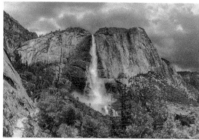

The first half, to Columbia Rock and beyond, provides stunning views of Upper Yosemite Fall, and you could turn around here for 2–3 hour 3-mile (5 km) round trip. The second half is steep but a memorable achievement.

✉ **Addr:**	Yosemite Falls, Yosemite Village CA 95389	♥ **Where:**	37.7552303 -119.6001934	
☽ **When:**	Afternoon	👁 **Look:**	East-northeast	
📷 **Lens:**	28mm	W **Wik:**	Yosemite_Falls	

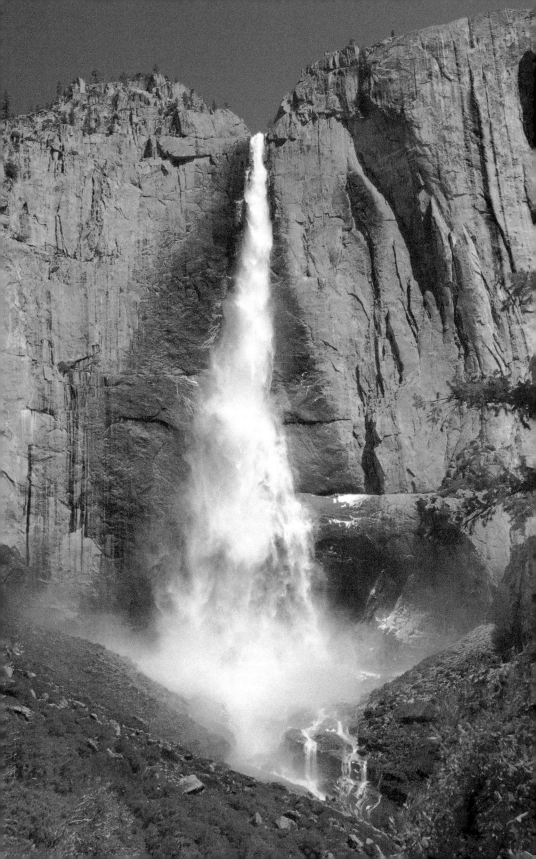

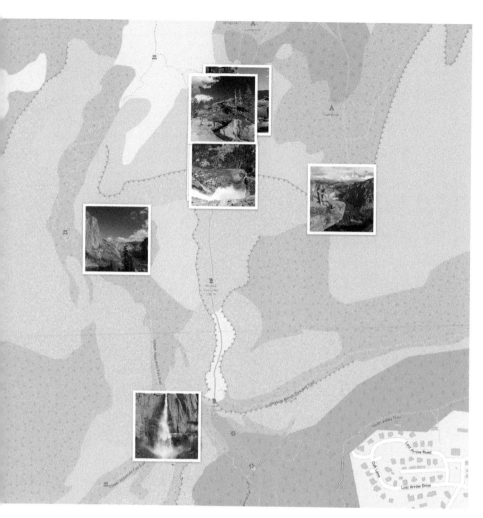

 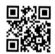

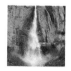 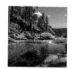

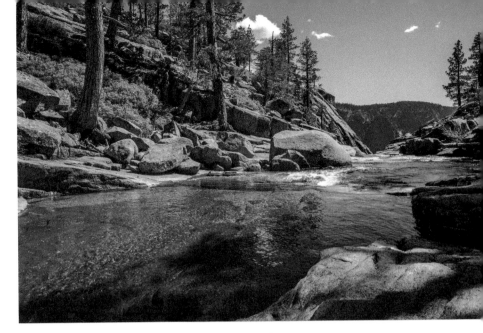

At the top, Yosemite Creek is crossed by a small bridge.

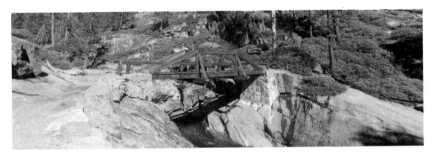

Use caution when near the creek as you are directly above a waterfall.

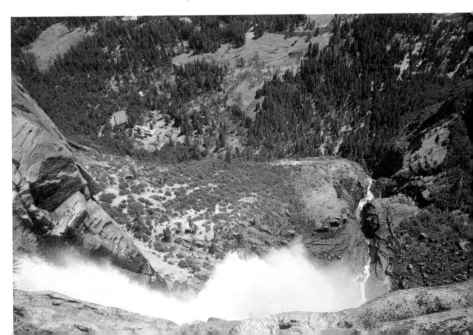

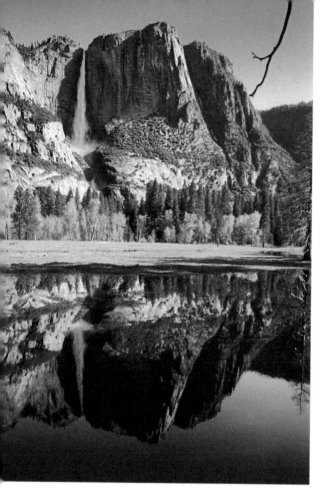

Yosemite Falls from north of Swinging Bridge

uses the Merced River as a reflecting pool, doubling the towering view.

This viewpoint is reached from Southside Drive, or by crossing Swinging Bridge from the Yosemite Falls Trailhead Parking Lot.

✉ **Addr:**	Southside Drive, Yosemite Valley CA 95389	♥ **Where:**	37.740215 -119.598967
☽ **When:**	Afternoon	👁 **Look:**	North
📷 **Lens:**	35mm	W **Wik:**	Yosemite_Falls

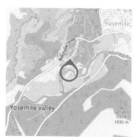

Half Dome from north of Swinging Bridge has a peaking view of the signature rock face. This shot is from southwest of the river.

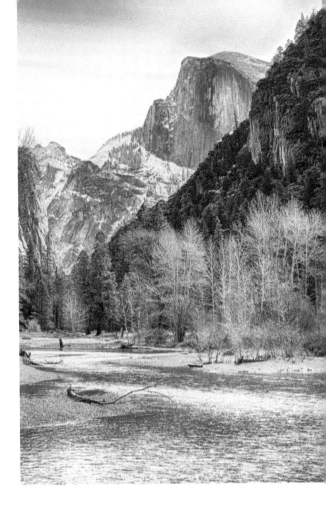

✉ **Addr:**	Southside Drive, Yosemite Valley CA 95389	♀ **Where:**	37.7396155 -119.5978429
◑ **When:**	Afternoon	◉ **Look:**	East
◎ **Lens:**	35mm	W **Wik:**	Half_Dome

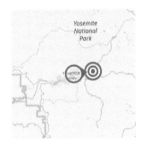

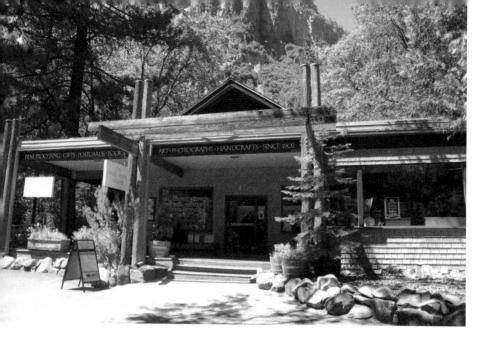

The **Ansel Adams Gallery** in Yosemite Village is a great place to meet fellow photographers, and learn from the master.

Ansel Adams and his wife, Virginia Best, operated this building from 1936–1971 as a photography studio, which was founded by Virginia's father in 1902. It remains owned by the Adams family.

Born in San Francisco, Ansel Adams was given his first camera at age 12, on his first visit to Yosemite. He developed a "pure" style of photography, with contrast, clarity and expert printing.

In 1927, Adams created *Monolith, the Face of Half Dome* with a dark red filter to heighten the tonal contrasts, a departure from all previous photography. With one glass plate left, he "visualized" the effect, to capture "how it *felt* to me and how it must appear in the finished print."

✉ **Addr:**	9031 Village Dr, Yosemite Valley CA 95389	♀ **Where:**	37.7484967 -119.5869618	
◑ **When:**	Afternoon	◉ **Look:**	East-northeast	
◎ **Lens:**	35mm	W **Wik:**	Ansel_Adams	

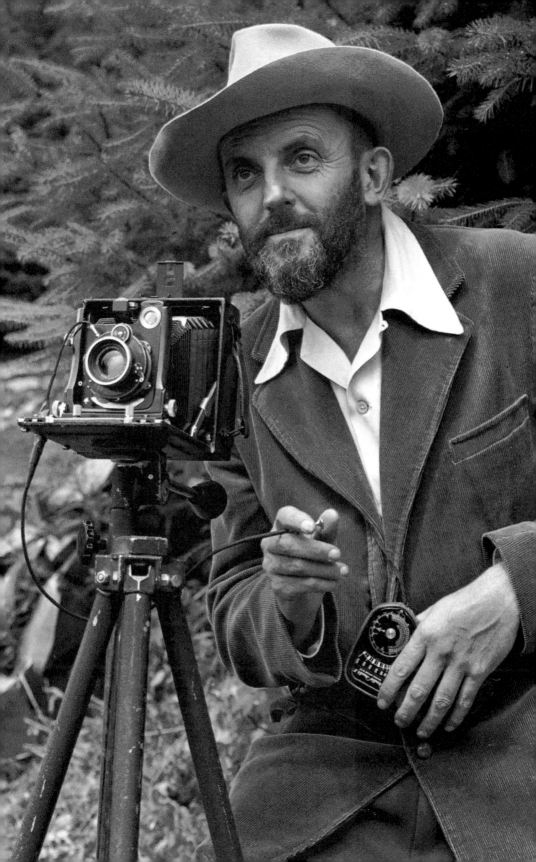

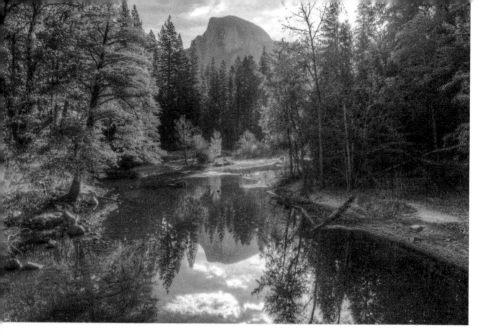

Half Dome from Sentinel Bridge is a classic view that can be taken year round. In the winter, this road bridge in the center of valley is always accessible. In the fall, trees turn beautiful shades of orange.

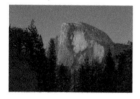

The road bridge has a pedestrian path which gives solid footing for a tripod. Notice how a horizontal format shows the width of the river while a vertical shot shows the height and grandeur of Half Dome.

✉ **Addr:**	Sentinel Bridge, Yosemite Valley CA 95389	♀ **Where:**	37.7433668 -119.5896276
◑ **When:**	Afternoon	👁 **Look:**	East
📷 **Lens:**	50mm	W **Wik:**	Half_Dome

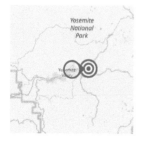

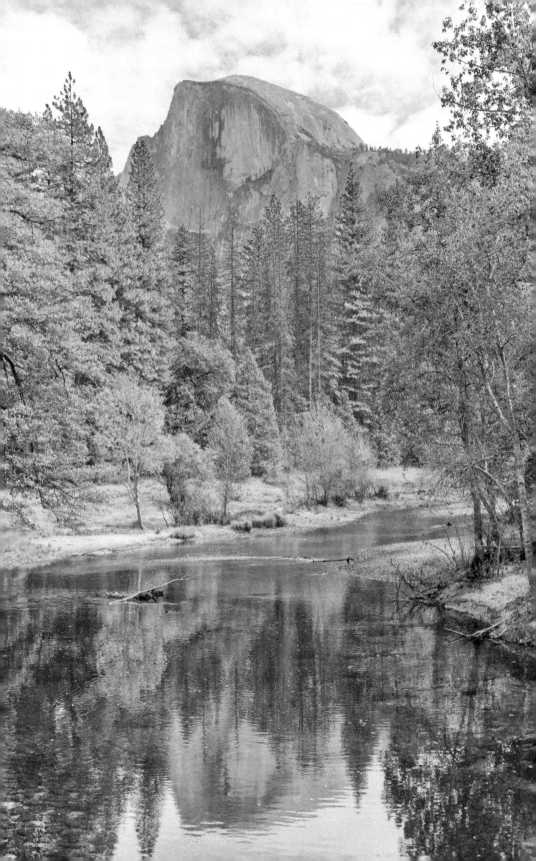

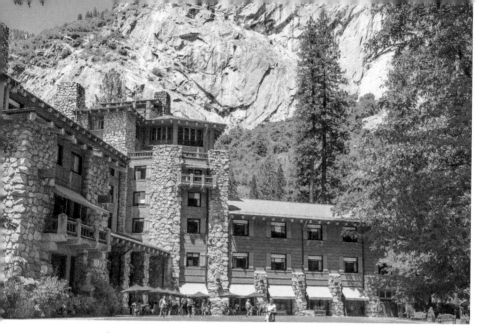

The **Majestic Yosemite Hotel** (formerly the Ahwahnee Hotel) is one of America's greatest grand hotel. Opened in 1927, it is a premier example of National Park Service rustic architecture and was declared a National Historic Landmark in 1987.

The name was changed from "The Ahwahnee" in 2016, due to a legal dispute with the outgoing concessionaire, Delaware North, which claims rights to the trademarked name.

Designed by Gilbert Stanley Underwood, who also made the Grand Canyon North Rim Lodge, the hotel is made to feel rustic and match its surroundings, and is considered a masterpiece of "parkitecture."

The interior, by husband and wife team Phyllis Ackerman and Arthur Pope, mixes Art Deco, Native American and Arts and Crafts styles.

✉ **Addr:**	1 Ahwahnee Drive, Yosemite Valley CA 95389	♀ **Where:**	37.745841 -119.573707
☀ When:	Morning	👁 **Look:**	Northwest
📷 **Lens:**	50mm	W **Wik:**	Ahwahnee_Hotel

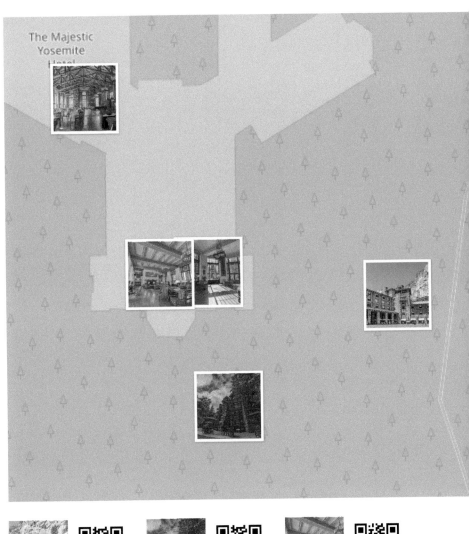

The Majestic
Yosemite
Hotel

 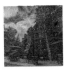 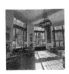 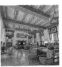 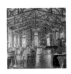

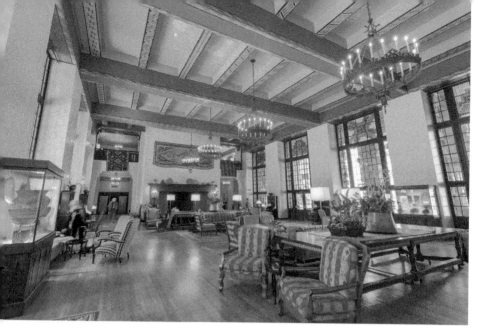

The Great Lounge (above) inspired the hotel design in *The Shining* (1980).

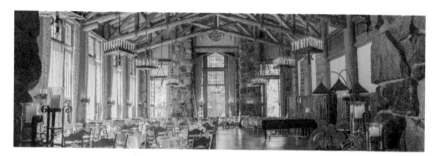

The dining room and solarium.

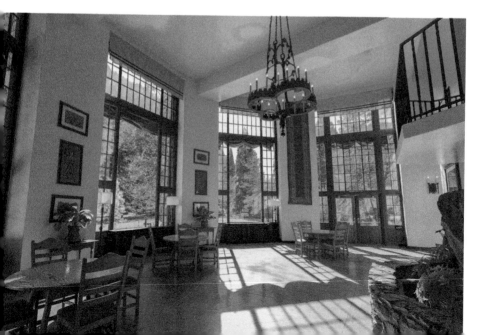

Half Dome from south of the Village

captures the full face of the signature rock face, which glows golden at sunset.

This shot is taken from an S-bend in the river, on the northwest bank by the main Visitor Parking area in Yosemite Village.

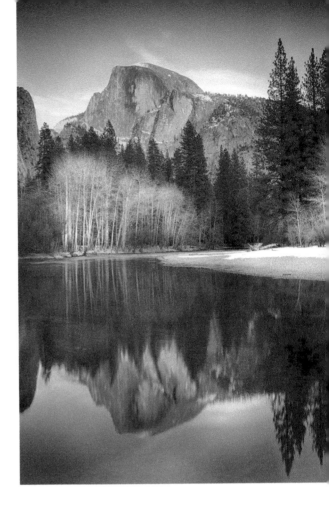

✉ **Addr:**	Northside Drive, Yosemite Valley CA 95389	♀ **Where:**	37.7438622 -119.5828476	
◐ **When:**	Sunset	👁 **Look:**	East	
📷 **Lens:**	50mm	W **Wik:**	Half_Dome	

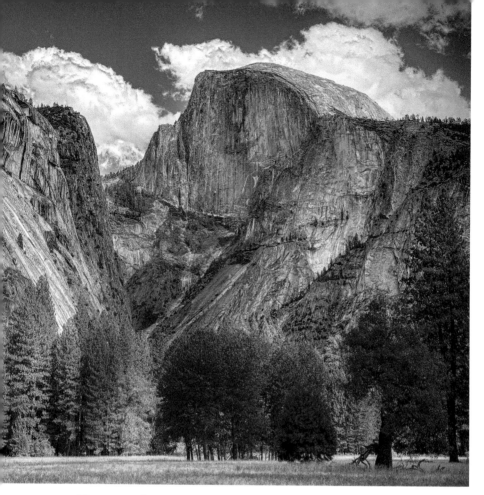

Half Dome from Majestic Meadow is across the meadow southwest of the Majestic Yosemite Hotel. This is the rare shot that benefits from being "flat" with a compressed depth courtesy of a long lens.

✉ **Addr:**	Northside Drive, Yosemite Valley CA 95389	♀ **Where:**	37.7455668 -119.5813866
◑ **When:**	Afternoon	◉ **Look:**	East
📷 **Lens:**	50mm	W **Wik:**	Half_Dome

The **Yosemite Valley Chapel** was built in 1879 and is the oldest standing structure in Yosemite National Park. The simple Carpenter Gothic style chapel was designed by San Francisco architect Charles Geddes in the Carpenter Gothic style, and built by his son-in-law, Samuel Thompson, for the California State Sunday School Association.

 From the south corner (next page), you can include Yosemite Falls in your shot. To show the chapel dwarfed by its magnificent surroundings, cross the meadow and stand near the river.

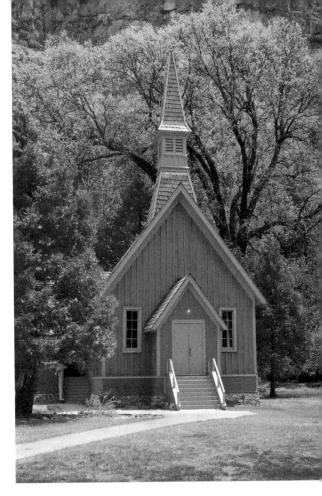

✉ **Addr:**	9000 Southside Drive, Yosemite Valley CA 95389	♀ **Where:**	37.741012 -119.591628
When:	Afternoon	👁 **Look:**	North
📷 **Lens:**	50mm	W **Wik:**	Yosemite_Valley_Chapel

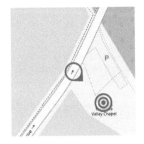

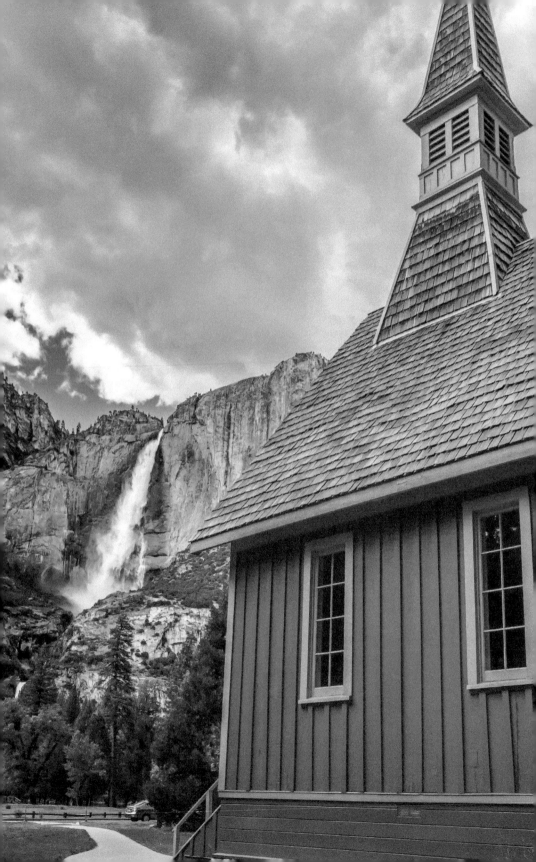

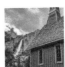

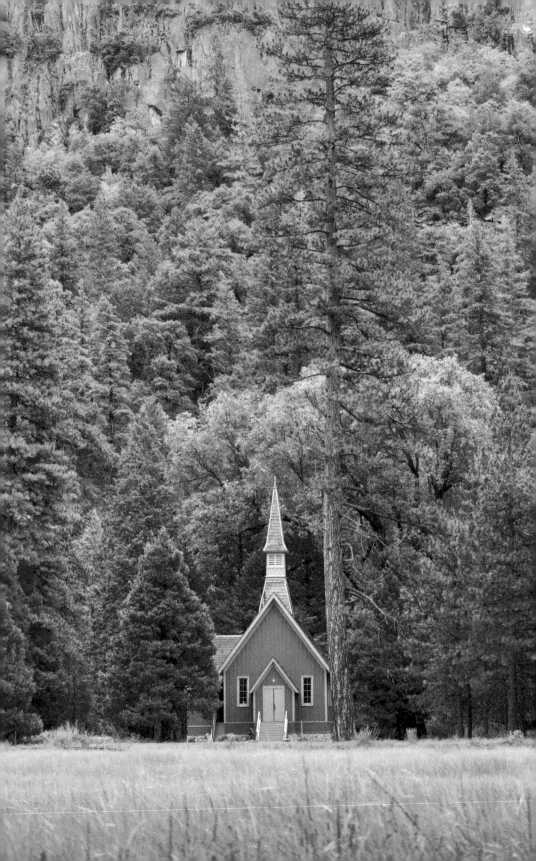

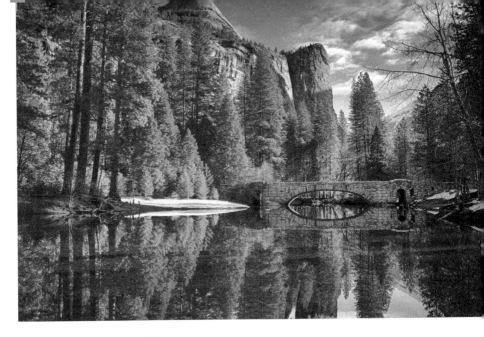

The **Stoneman Bridge** was built in 1933 in rustic style with equestrian subways in the abutments. Beyond is North Dome (top left) and the entrance to Tenaya Canyon.

This is the eastern junction of Northside Drive and Southside Drive, six miles (10 km) from the western junction by Valley View.

✉ **Addr:**	Northside Drive, Yosemite Valley CA 95389	♀ **Where:**	37.739923 -119.575195
When:	Anytime	👁 **Look:**	East-northeast
📷 **Lens:**	28mm	W **Wik:**	Yosemite_Valley_Bridges

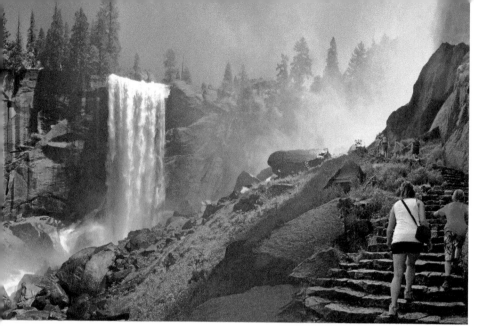

Vernal Fall is a 317-foot waterfall on the Merced River which flows all year long, although by the end of summer it is substantially reduced in volume and can split into multiple strands, rather than a single curtain of water.

The waterfall is reached by the suitably named Mist Trail, one of the shortest (1.3 miles / 2.1 km) and most popular trails in Yosemite. The trail is mostly shaded and is progressive in incline until it reaches the base of the waterfall where mist sprays onto the hikers.

At times of high flow, mostly in the spring, hikers may be drenched by the time they pass the mist from the waterfall. The final 15 minutes of the trail is a very steep climb up rocks to the top of the waterfall. Once atop the falls there is a pool of water called the Emerald Pool around which hikers lounge and rest.

✉ **Addr:**	Mist Trail, Yosemite Valley CA 95389	♀ **Where:**	37.7269801 -119.544864	
◐ **When:**	Afternoon	◉ **Look:**	East-northeast	
◉ **Lens:**	28mm	W **Wik:**	Vernal_Fall	

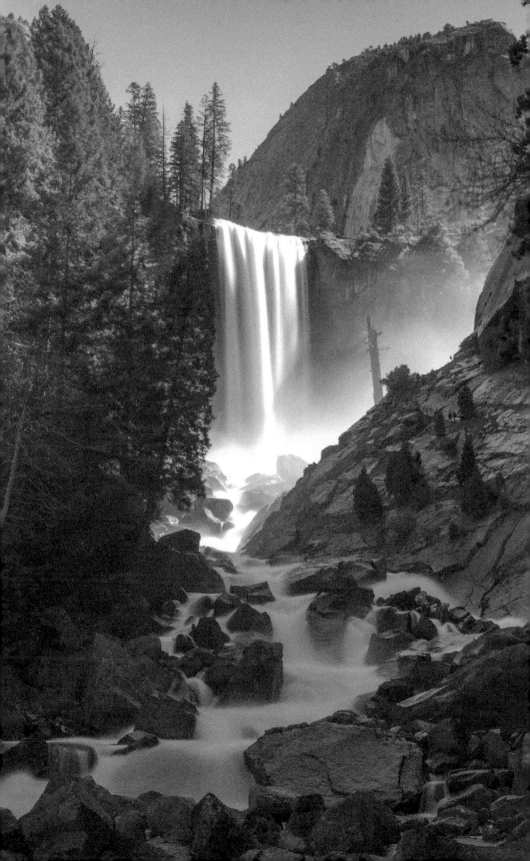

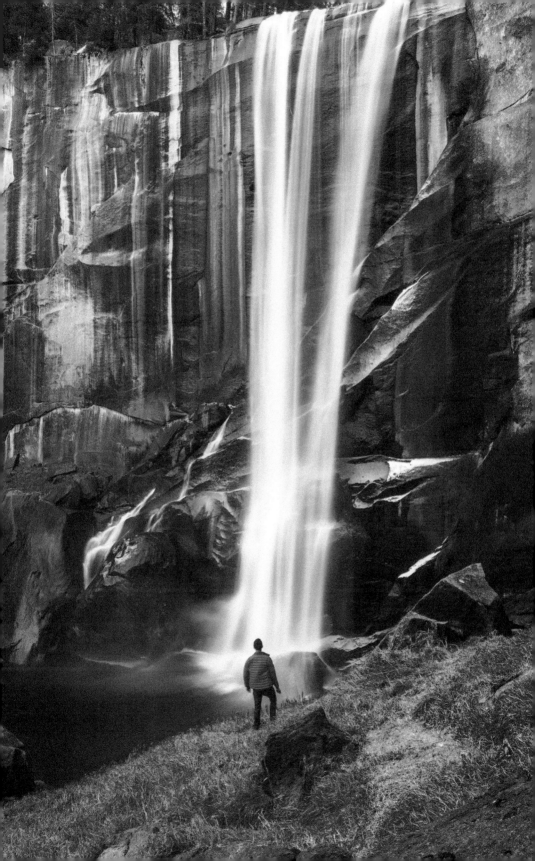

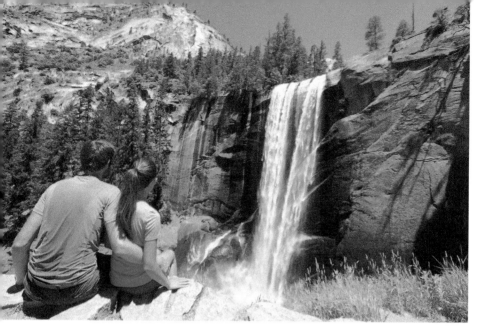

Views from the Mist Trail.

The Mist Trail rises above the fall, then to the very edge of Vernal Fall.

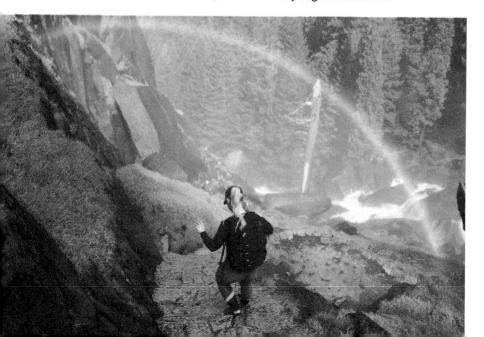

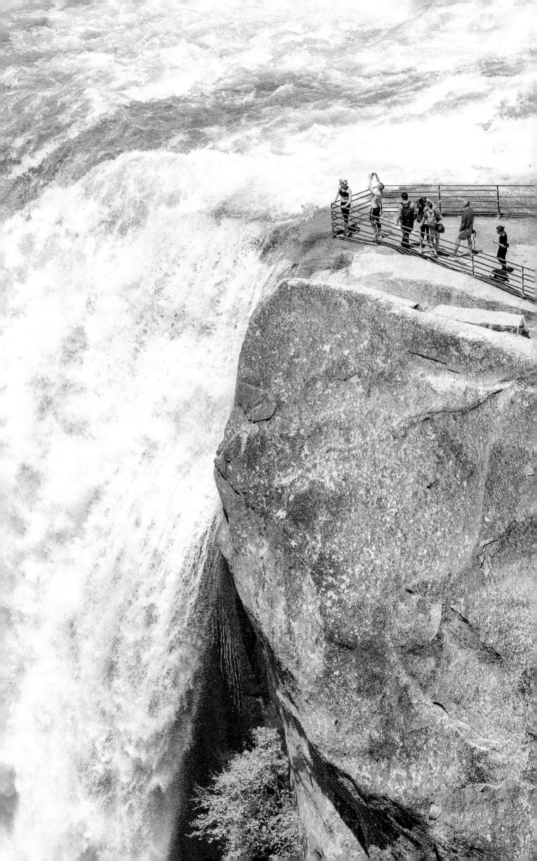

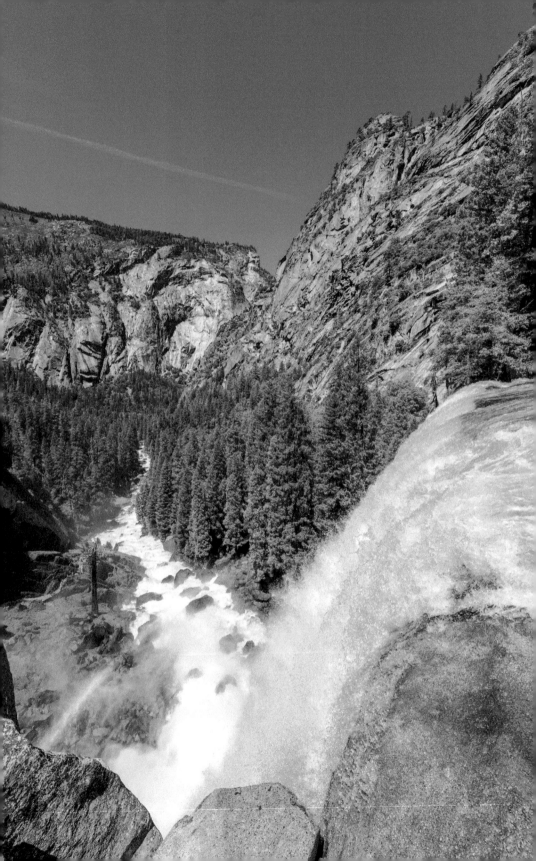

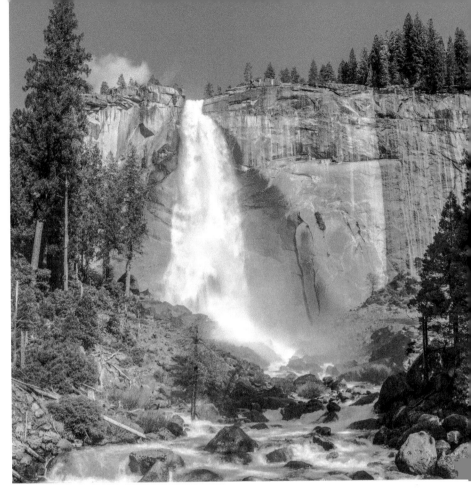

Nevada Fall is a 594-foot high waterfall on the Merced River above Vernal Fall. From the trailhead in Yosemite Valley, the hike to the top of Nevada Fall, along the Mist Trail, is 3 miles (4.8 km), and includes a view from slightly above the waterfall (next page) with Liberty Cap.

✉ **Addr:**	John Muir Trail, Yosemite Valley CA 95389	♀ **Where:**	37.726033 -119.537451
◑ **When:**	Afternoon	👁 **Look:**	East-southeast
📷 **Lens:**	35mm	Ⓦ **Wik:**	Nevada_Fall

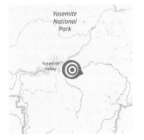
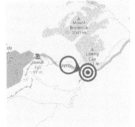

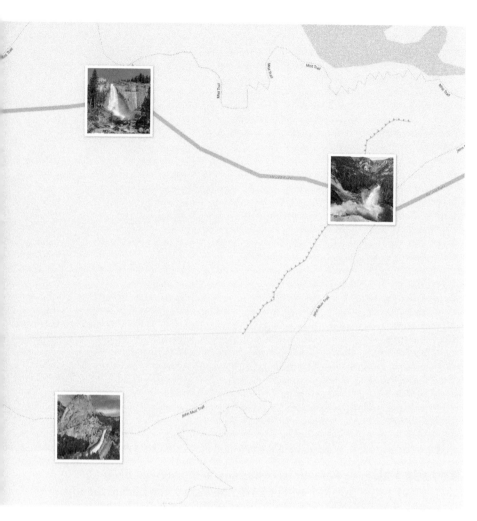

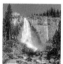

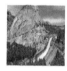

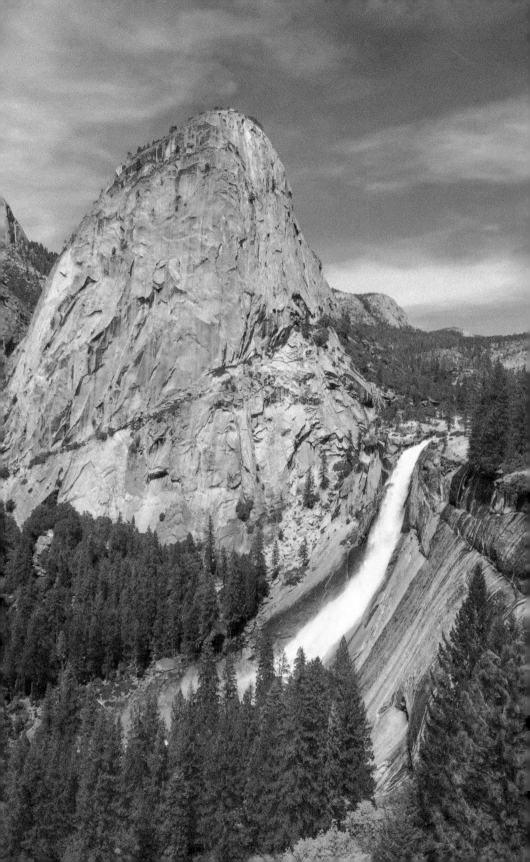

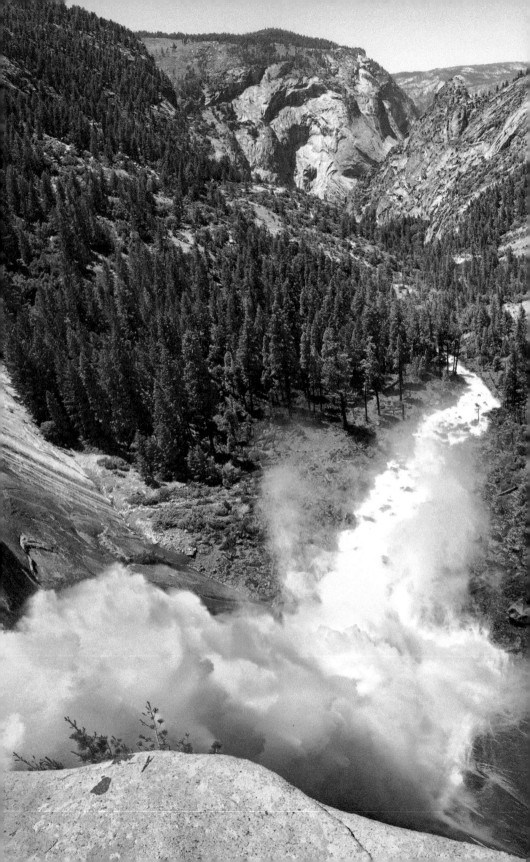

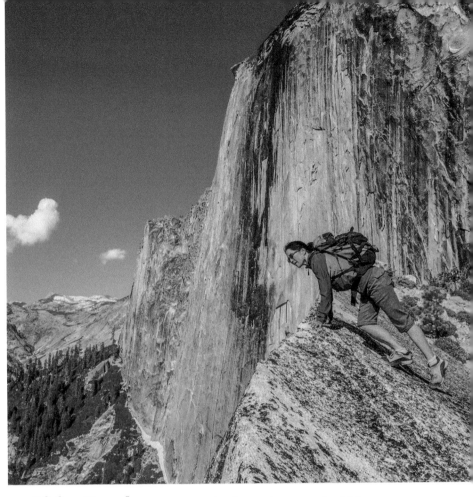

The **Diving Board** is where Ansel Adams photographed his landmark image *Monolith, the Face of Half Dome* (1927). I encountered the recent tracks of bear and her cubs on this hike, which is about three miles after Nevada Fall. BTW, no diving from the Diving Board.

✉ **Addr:**	Half Dome, Yosemite Valley CA 95389	♀ **Where:**	37.742338 -119.541204
☾ **When:**	Afternoon	◉ **Look:**	East-northeast
☐ **Lens:**	28mm	W **Wik:**	Ansel_Adams#Monolith

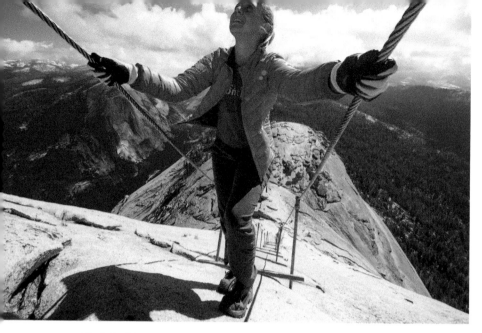

The **Cable Route** up Half Dome is the final 400 ft (120 m) ascent with steel cables for handholds (May–October). A permit is required in advance and the strenuous hike from the valley floor (via the Mist Trail) takes 10–12 hours.

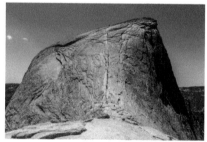

✉ **Addr:**	Half Dome Trail, Yosemite Village CA 95389	♀ **Where:**	37.746426 -119.530593
◑ **When:**	Morning	◉ **Look:**	West-southwest
📷 **Lens:**	28mm	W **Wik:**	Half_Dome#Hiking_the_Cable_Route

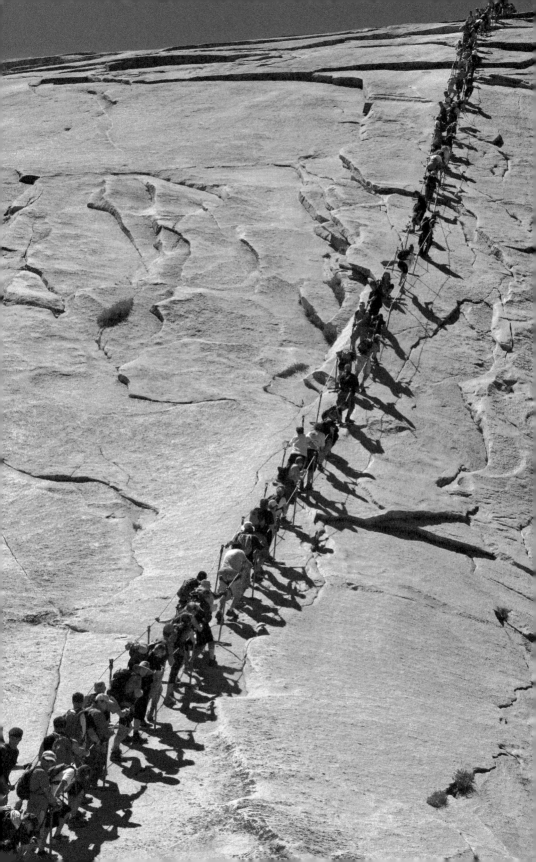

The Cables

Half Dome Trail

The Cables

The Trail

The Trail

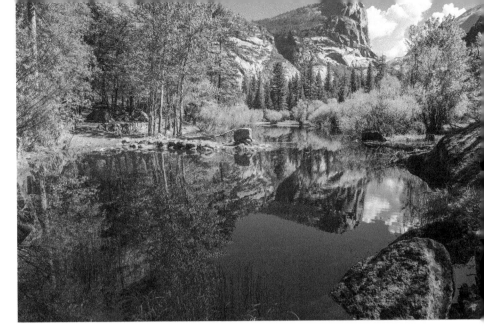

Mirror Lake is a small, seasonal lake located below Half Dome on Tenaya Creek, with a view of Mt Watkins. The flat hike is two miles (3.2 km) round trip to the lake and back, which takes about an hour, or five miles (8 km) looping around the lake (2–3 hours).

The lake is only full in spring and early summer, when Tenaya Creek flows freely with fresh snowmelt. In the summer, Mirror Lake becomes Mirror Meadow.

✉ **Addr:**	Mirror Lake Trail, Yosemite Village CA 95389	♀ **Where:**	37.7466 -119.550766
☉ **When:**	Afternoon	◉ **Look:**	Northeast
⊙ **Lens:**	35mm	W **Wik:**	Mirror_Lake_(California)

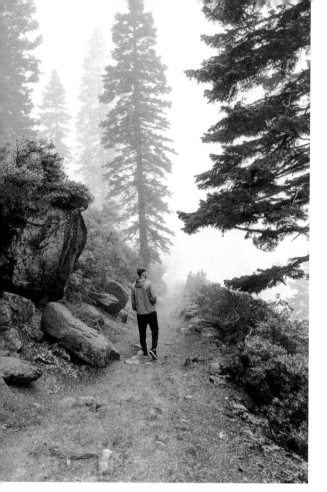

Four Mile Trail is a moderate to strenuous trail leading from Yosemite Valley to Glacier Point. Constructed in 1872, the trail was rebuilt in the early 1900s and lengthened, so that it is now 4.8 miles (7.7 km). The elevation change is 3,200 feet (1,000 m).

✉ **Addr:**	Four Mile Trail, Yosemite Valley CA 95389	♀ **Where:**	37.735713 -119.588665
When:	Anytime	◉ **Look:**	West-southwest
📷 **Lens:**	50mm	W **Wik:**	Four_Mile_Trail

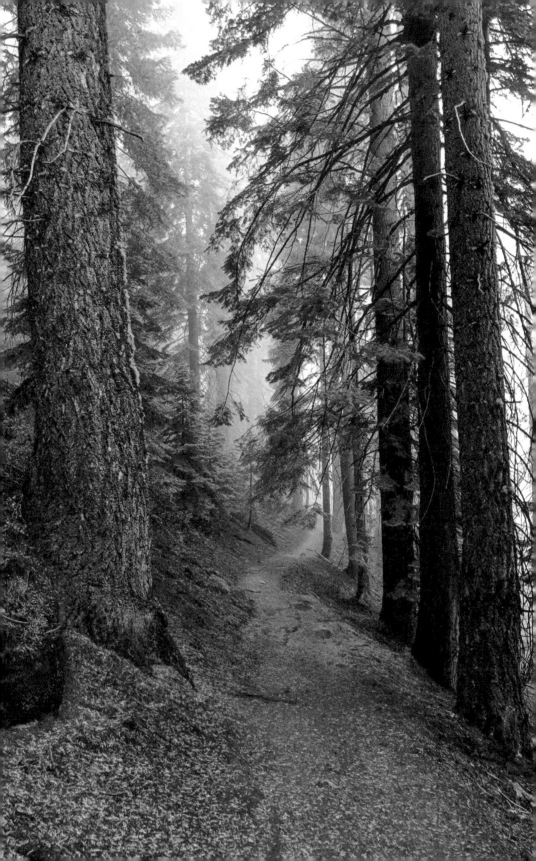

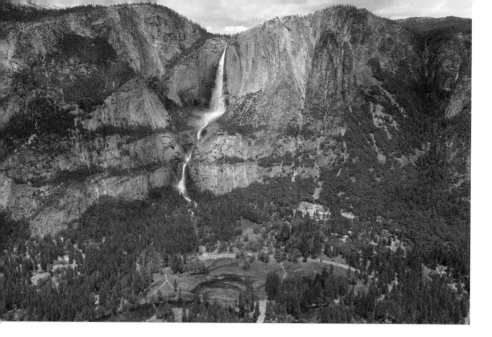

Yosemite Falls from the Four Mile Trail is a view from half-

way up, at the two-mile point. You have a panoramic view of Yosemite Valley and its signature waterfall.

What lens size do you need? Let's calculate. Yosemite Falls is 740 m (2,425 feet) tall. We'll add 10 m (32 feet) for some sky, so that's 750 m. The waterfall is located 2.5 km (1.5 miles) away. Divide the distance to the subject by the width or height of the subject, then multiply by the sensor size (for a standard 35mm camera the sensor is actually 36mm wide). Thus the focal length is (2500m / 750m) × 36mm = 120mm.

✉ **Addr:**	Four Mile Trail, Yosemite Valley CA 95389	♀ **Where:**	37.735865 -119.587426
◑ **When:**	Morning	◉ **Look:**	North-northwest
◙ **Lens:**	120mm	W **Wik:**	Yosemite_Falls

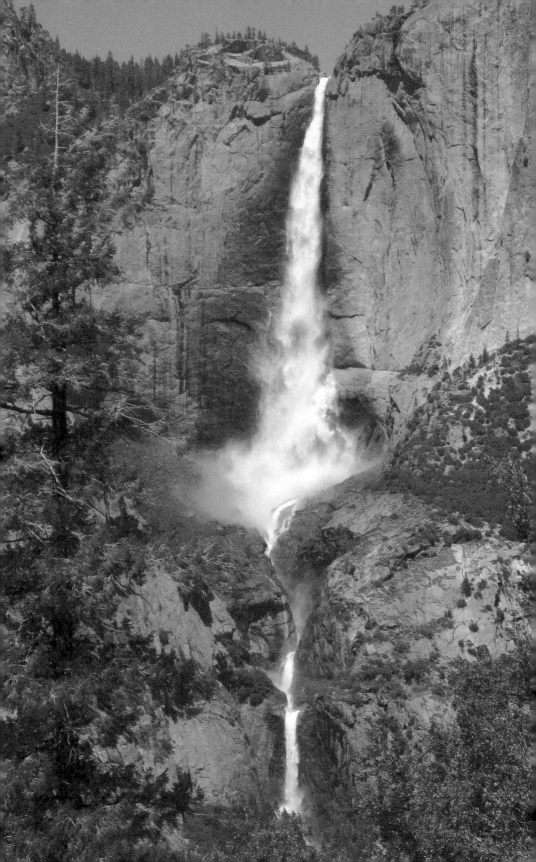

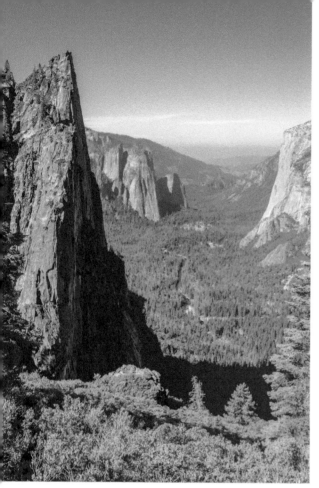

Sentinel rock and El Capitan from the three-mile point of Four-Mile Trail.

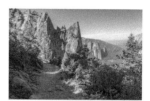

The trail is hazardous when covered with snow or ice, so it is usually closed by the Park Service from December through May.

✉ **Addr:**	Four Mile Trail, Yosemite Valley CA 95389	♥ **Where:**	37.732711 -119.5867007	
◑ **When:**	Morning	👁 **Look:**	West	
📷 **Lens:**	35mm	W **Wik:**	Sentinel_Rock	

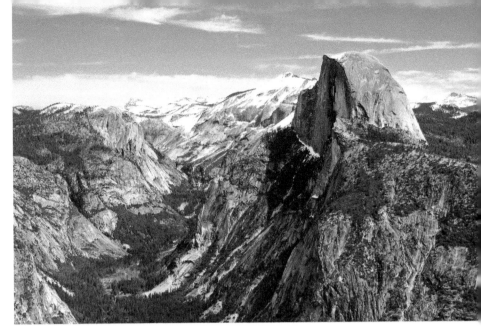

Glacier Point offers high views of Tenaya Canyon, Clouds Rest and Half Dome. Located on the south wall of Yosemite Valley at an elevation of 7,214 feet (2,199 m), Glacier Point can be reached from the Valley by car/bus via Glacier Point Road. The road is usually open from June through October, and closes in winter due to snow.

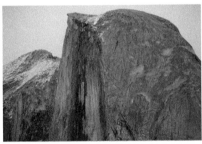

The cover shot is taken at sunset from the Glacier Point Amphitheater. You can walk 800 feet (250 m) north or south of here for slightly different views.

✉ **Addr:**	Four Mile Trail, Yosemite Village CA 95389	♀ **Where:**	37.730974 -119.573009
☽ **When:**	Sunset	◉ **Look:**	East-northeast
◉ **Lens:**	35mm	W **Wik:**	Glacier_Point

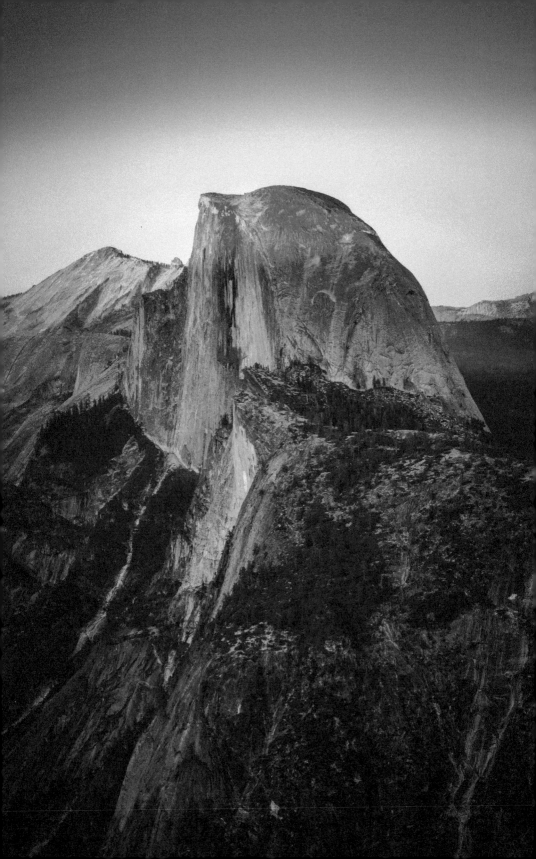

 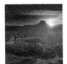 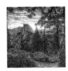 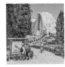

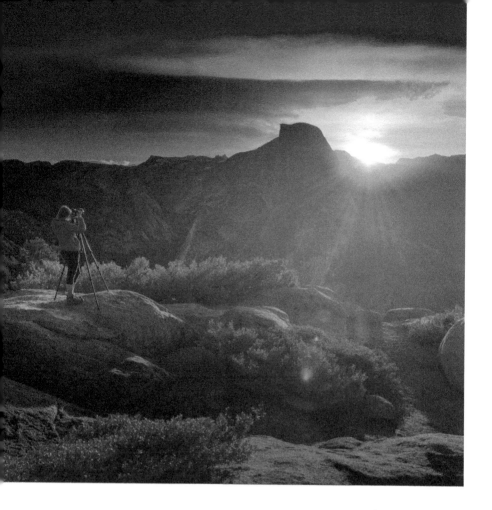

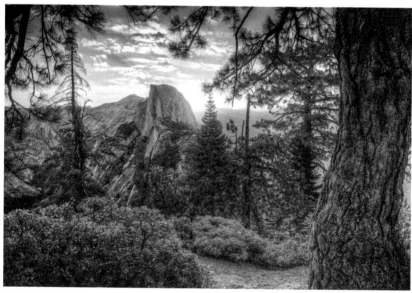

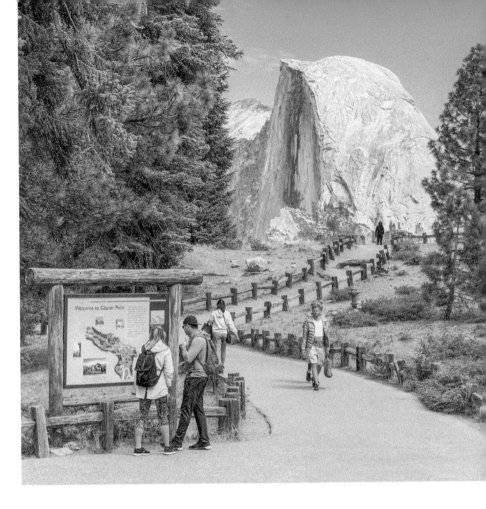

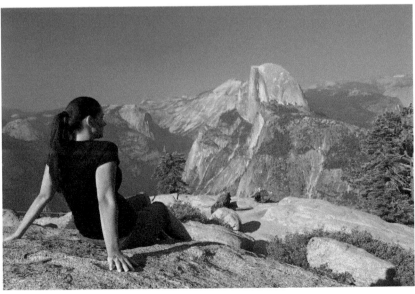

5 South Valley / Glacier Point > Glacier Point > Half Dome

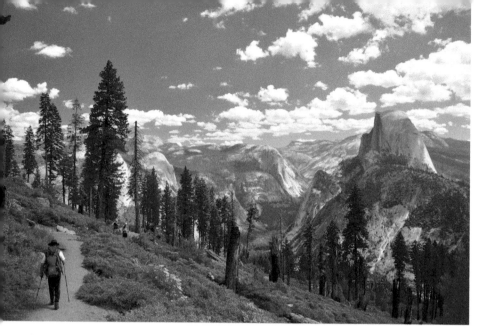

Washburn Point is about 0.6 miles (900 m) south of Glacier Point and offers a flatter profile of Half Dome. There's also a good view of Vernal Fall and the Mist Trail (next page).

The Panorama Trail from Glacier Point crosses nearby on its way to Illilouette Falls and Nevada Fall (4.3 miles / 7 km).

✉ **Addr:**	Washburn Point, Yosemite Valley CA 95389	♀ **Where:**	37.7263089 -119.5733231	
◑ **When:**	Afternoon	◉ **Look:**	East	
◎ **Lens:**	28mm	W **Wik:**	Glacier_Point	

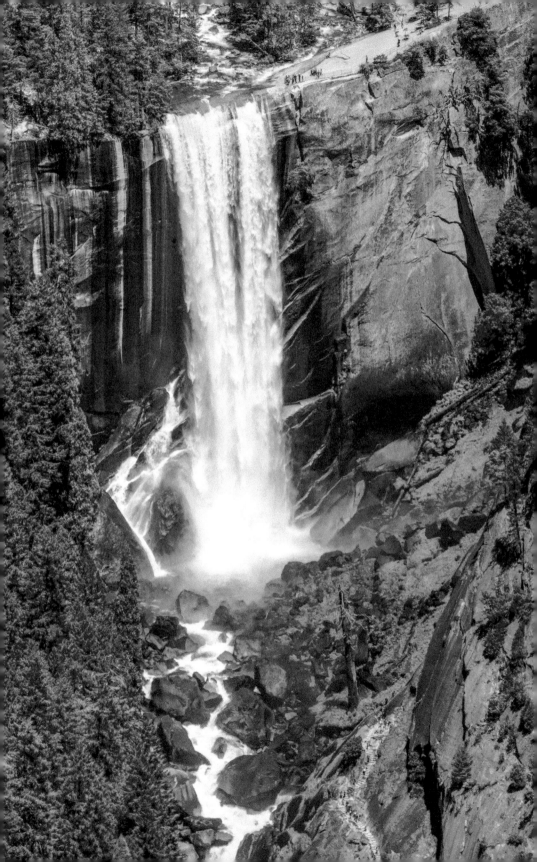

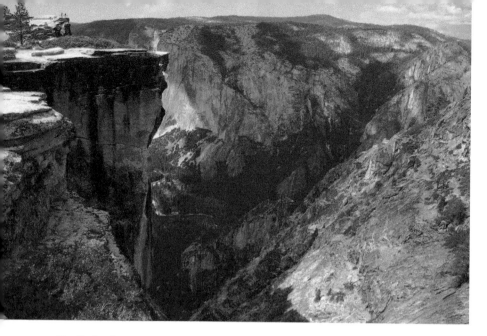

Taft Point is another south-wall overlook, two miles (3.2 km) west-southwest from Glacier Point. A preceding promontory (above) provides a good vantage point to photograph Taft Point (next page, with the people) with El Capitan beyond.

The point is named after 27th President of the United States William Howard Taft who reportedly had lunch here with John Muir in 1909.

Nearby are "The Fissures", breaks and cracks in the mountain that drop directly down to the valley floor at some points.

Taft Point can be reached from Glacier Point Road at the Sentinel Dome Trailhead. I crossed paths with a bear once on this hike. The fairly-flat trail is about 2.2 miles (4 km) round trip.

✉ **Addr:**	Taft Point, Yosemite Valley CA 95389	♀ **Where:**	37.712852 -119.6036
☽ **When:**	Morning	👁 **Look:**	West-northwest
📷 **Lens:**	28mm	W **Wik:**	Taft_Point

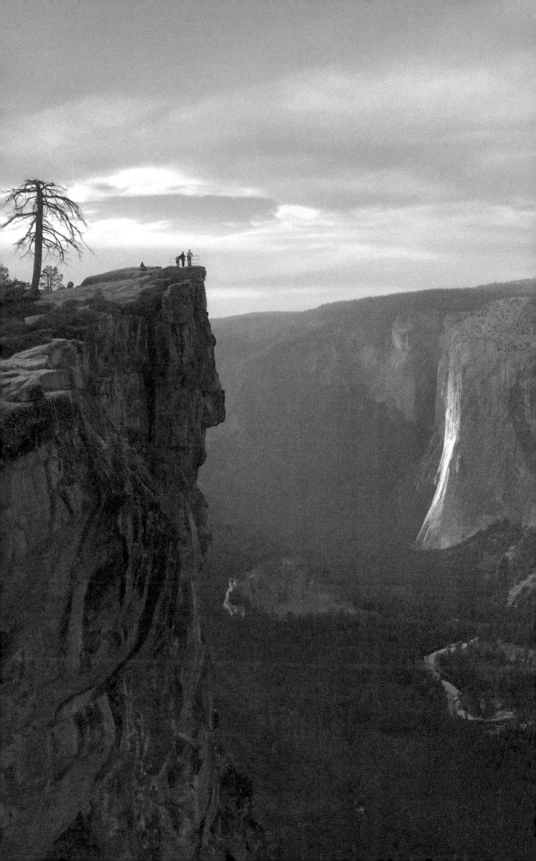

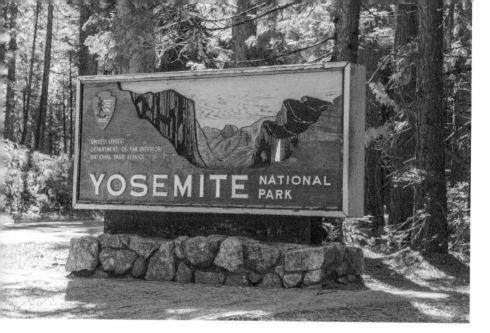

Welcome to Yosemite National Park sign.

Now that we've photographed the main sights of Yosemite Valley we can explore the other 99% of the park. A good place to start is at the entrance. The road from San Francisco (CA-120) enters at Big Oak Flat where you can photograph this atmospheric sign to make a great establishing shot (and/or a selfie). A fun way to add variety to your travel shots is to photograph signs, directions, maps, tickets, souvenirs and other mementos.

✉ **Addr:**	6107 Big Oak Flat Road, Groveland CA 95321	♀ **Where:**	37.802809 -119.873802
☽ **When:**	Morning	◉ **Look:**	South-southwest
📷 **Lens:**	50mm	↔ **Far:**	15 m (49 feet)

Big Oak Flat Road Tunnel

Big Oak Flat Road Tunnel is preceded by a snaking road to draw the eye into the tunnel. There is a pullout here.

This tunnel is about 16 miles (25 km) from the Big Oak Flat entrance. CA-120 at Crane Flat becomes the Tioga Road, which continues east, while Big Oak Flat Road splits south toward Yosemite Valley and the Merced River.

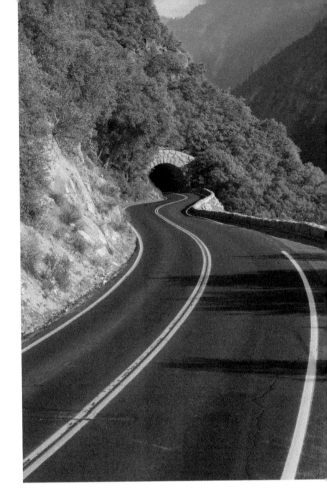

✉ **Addr:**	Big Oak Flat Road, Yosemite NP CA 95389	♀ **Where:**	37.7237712 -119.7007583
◑ **When:**	Afternoon	◉ **Look:**	East-southeast
📷 **Lens:**	28mm	↔ **Far:**	150 m (490 feet)

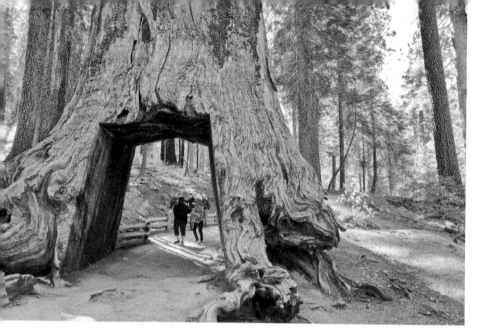

Dead Tunnel Tree is the other-worldly remains of a giant sequoia. The tree is located in Tuolumne Grove, in the Crane Flat area off CA-120 (Tioga Road / Big Oak Flat Road). From the trailhead, walk just over a mile (1.8 km) and photograph both sides of the old tree.

✉ **Addr:**	Old Big Oak Flat Road, Yosemite NP CA 95321	♥ **Where:**	37.768581 -119.80562
◑ **When:**	Morning	◉ **Look:**	South-southwest
📷 **Lens:**	28mm	W **Wik:**	Tuolumne_Grove

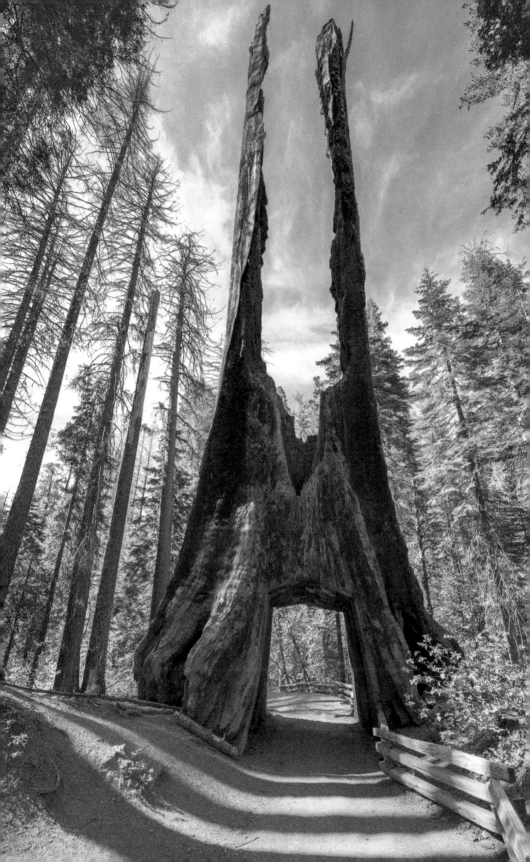

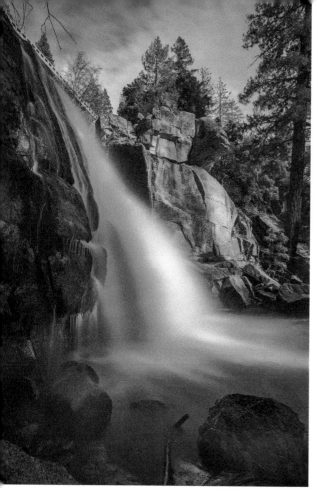

The Cascades under Big Oak Flat Road

is another magnificent waterfall shot. Cascade Creek flows under a bridge, built in 1939, and crashes down toward the Merced River. There are actually three bridges here, for Wildcat Creek (first/west) then for Tamarack Creek and Cascade Creek, which join and flow south.

Unfortunately no parking areas are nearby, just a few small pullouts. Be careful if taking these shots as the creek later drops as a large waterfall, visible from El Portal Road.

✉ **Addr:**	Big Oak Flat Road, Yosemite NP CA 95389	♀ **Where:**	37.726024 -119.713699
☾ **When:**	Afternoon	◉ **Look:**	North-northeast
📷 **Lens:**	35mm	↔ **Far:**	190 m (610 feet)

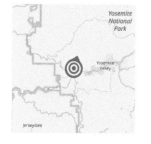

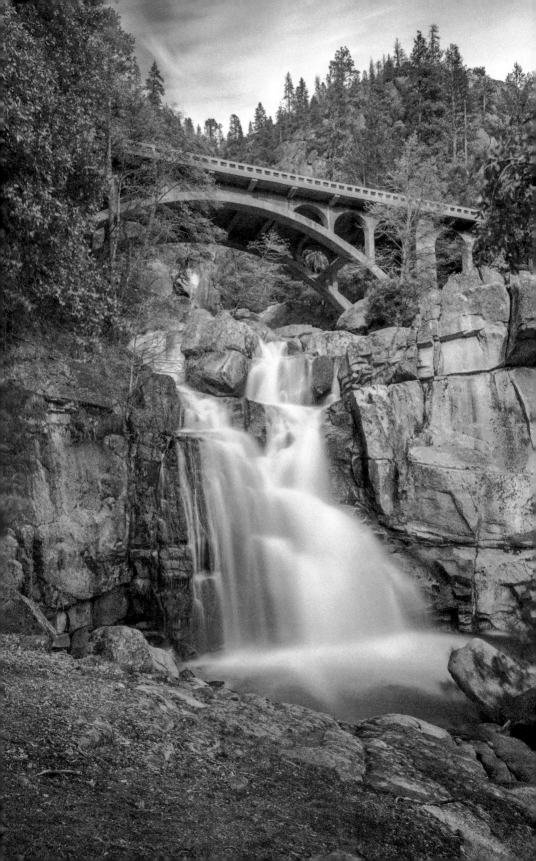

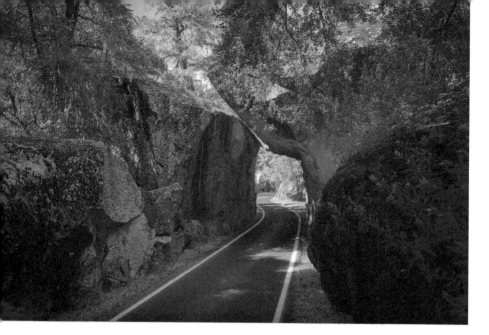

Arch Rock is a pair of almost-touching rocks under which the single-lane entrance road from El Portal passes. The sight is 650 feet (200 m) after you enter Yosemite National Park at the appropriately-named Arch Rock Entrance on CA-140. just past the El Portal entrance. You can walk from a nearby rest stop parking area.

✉ **Addr:**	804 El Portal Road, Wawona CA 95389	📍 **Where:**	37.6870316 -119.7298158
🌙 **When:**	Afternoon	👁 **Look:**	North-northeast
📷 **Lens:**	35mm	↔ **Far:**	60 m (180 feet)

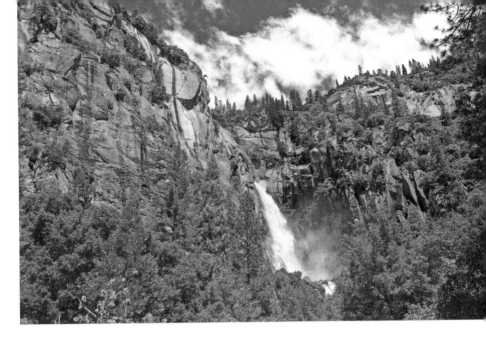

The Cascades from El Portal Road shows the power of

Tamarack Creek after the photography spots by Big Oak Flat Road.

This shot is from a viewpoint parking area off El Portal Road (CA-140). A quarter-mile (400 m) west is Wildcat Falls.

✉ **Addr:**	El Portal Road, Wawona CA 95389	📍 **Where:**	37.7240574 -119.7119787	
☾ **When:**	Morning	👁 **Look:**	West-southwest	
📷 **Lens:**	50mm	W **Wik:**	The_Cascades	

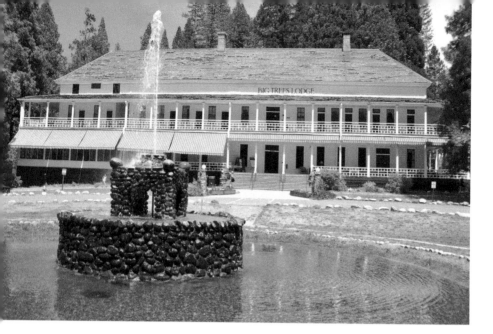

Big Trees Lodge

Big Trees Lodge is an historic hotel (formerly known as the Wawona Hotel) in the southwest corner of the park, in Wawona.

Built in 1876, this is one of the oldest mountain resort hotels in California, and a classic of Victorian era resort design. This shot is from the front of the hotel, using, as the ever-important foreground, the fountain and pond (which may not operate during drought periods).

Wawona is about four miles (6.4 km) past the park's south entrance, from Fresno and Southern California.

✉ **Addr:**	21103 Wawona Road, Wawona CA 95389	♀ **Where:**	37.536793 -119.6556
☾ **When:**	Afternoon	◉ **Look:**	East
☐ **Lens:**	28mm	W **Wik:**	Wawona_Hotel

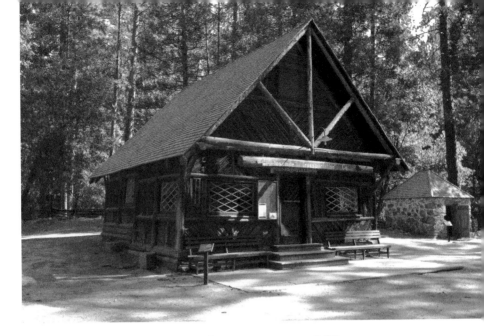

The **Yosemite Transportation Company Office**, also known as the Wells Fargo Office, was built in the Yosemite Valley in 1910 to house facilities of motor stage and horse stage services between the nearest rail terminal at El Portal and Yosemite National Park. The rustic log structure also provided telegraph and express services.

The historic building, along with ten others, is at the Pioneer Yosemite History Center in Wawona, about 500 feet (150 m) north of Big Trees Lodge.

✉ **Addr:**	4100 Forest Dr, Wawona CA 95389	♀ **Where:**	37.539156 -119.655761
When:	Afternoon	👁 **Look:**	South-southeast
📷 **Lens:**	35mm	W **Wik:**	Yosemite_Transportation_Company_Office

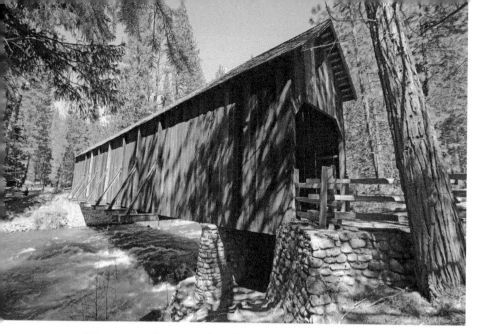

The **Wawona Covered Bridge** is one of only one of twelve remaining covered bridges in California. The historic and photogenic structure spans the South Fork of the Merced River, at the Pioneer Yosemite History Center.

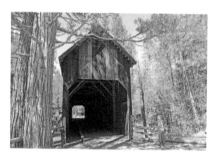

The bridge platform was built in 1868 by Galen Clark, the steward of what was then called the Yosemite Grant. Douglas fir cladding was added in 1878 and the bridge served automobile traffic until 1937.

✉ **Addr:**	4100 Forest Dr, Wawona CA 95389	♀ **Where:**	37.538418 -119.65609
◑ **When:**	Anytime	👁 **Look:**	North-northeast
📷 **Lens:**	28mm	W **Wik:**	Wawona_Covered_Bridge

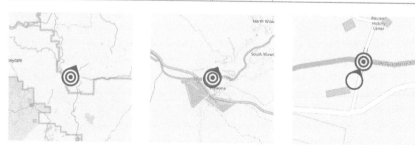

Mariposa Grove is the best place to photograph giant sequoia trees in Yosemite, with several hundred mature examples. The grove is located six miles (9 km) south of Wawona and two miles (3.3 km) past the southern entrance to Yosemite National Park. The road to the grove is closed in winter.

Giant sequoias are Earth's most massive trees, growing up to 56 feet (17 m) in diameter and over 300 feet (90 m) tall, and one of the oldest living organisms, living for over 3,000 years. They grow naturally only on the western slopes of the Sierra Nevada Mountains of California.

✉ **Addr:**	4726 Mariposa Grove Rd, Fish Camp CA 93623	♀ **Where:**	37.51389 -119.59833
◑ **When:**	Afternoon	◉ **Look:**	North
◎ **Lens:**	50mm	W **Wik:**	Mariposa_Grove

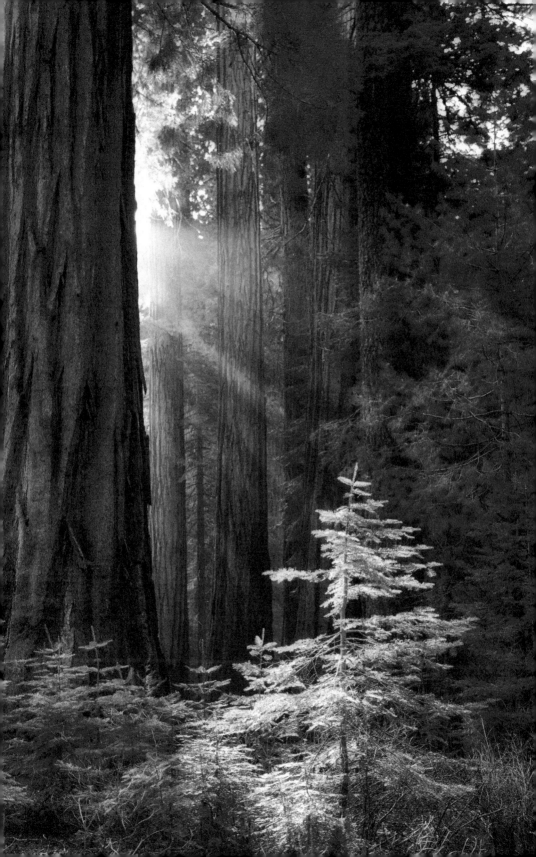

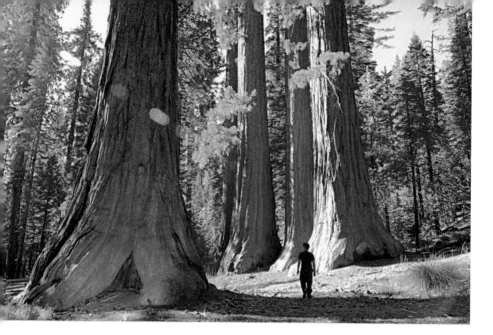

Bachelor and Three Graces are a group of four trees, three of them growing very close together, with a fourth a little more distant. Their roots are so intertwined that if one of them were to fall, it would likely bring the others along with it.

"The Big Tree (Sequoia gigantea) is Nature's forest masterpiece, and, so far as I know, the greatest of living things."
— John Muir, 1901.

✉ **Addr:**	4726 Mariposa Grove Rd, Fish Camp CA 93623	♀ **Where:**	37.5038975 -119.604552
☽ **When:**	Morning	◉ **Look:**	West-southwest
◉ **Lens:**	28mm	W **Wik:**	Mariposa_Grove

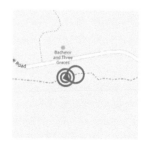

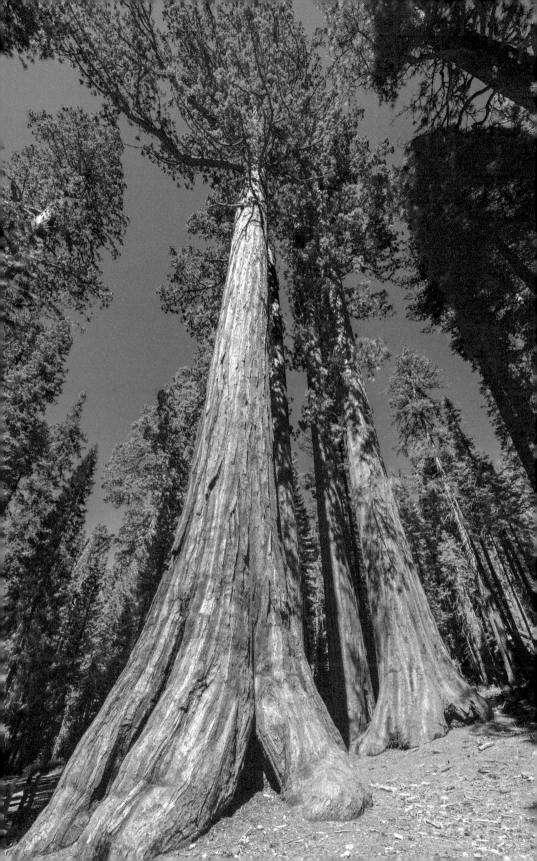

The **Grizzly Giant** is the oldest tree in the grove and the 25th largest giant sequoia living today. It is 209 feet (64 m) tall and has a circumference of 96 feet (29 m) at the base.

On our planet, this is reminiscent of the *Hometree* in James Cameron's 2009 movie *Avatar*.

✉ **Addr:**	Mariposa Grove Rd, Fish Camp CA 93623	♥ **Where:**	37.503404 -119.600915
☾ **When:**	Afternoon	👁 **Look:**	Northeast
📷 **Lens:**	35mm	W **Wik:**	Grizzly_Giant

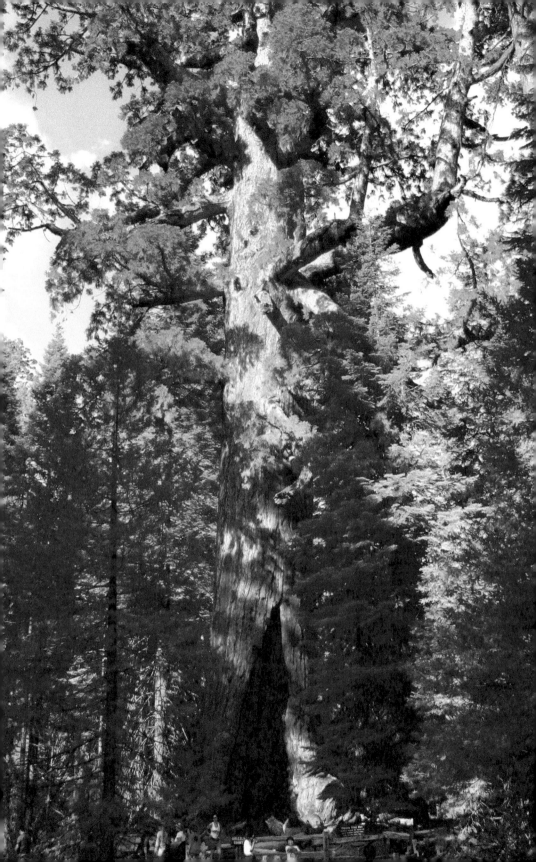

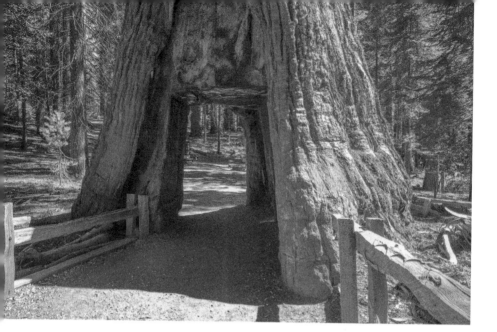

The **California Tunnel Tree** was cut in 1895 to allow coaches to pass through it (and as a marketing scheme to attract visitors to the grove), this is the only living Giant sequoia tree with a tunnel in it since the fall of the Wawona Tunnel Tree in 1969 and the fall of the Pioneer Cabin Tree in 2017.

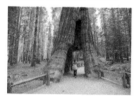

✉ **Addr:**	4726 Mariposa Grove Rd, Fish Camp CA 93623	♀ **Where:**	37.504435 -119.600252	
◑ **When:**	Afternoon	👁 **Look:**	South-southeast	
📷 **Lens:**	35mm	W **Wik:**	Mariposa_Grove	

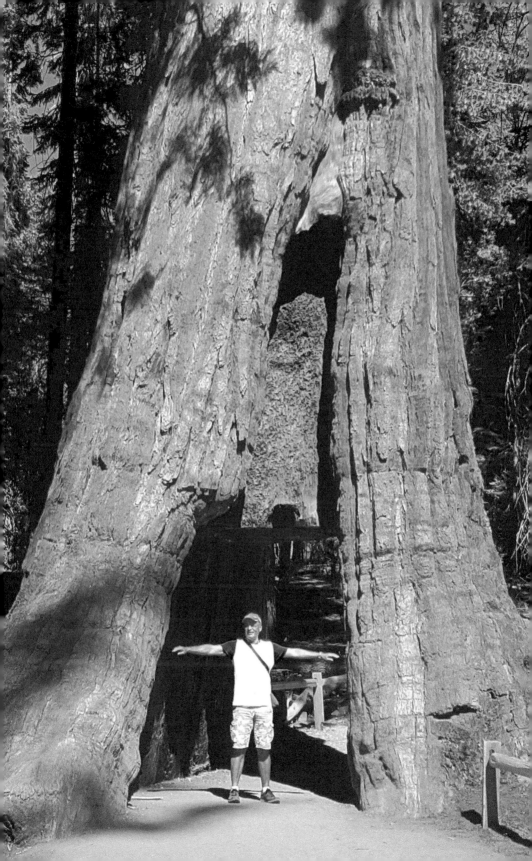

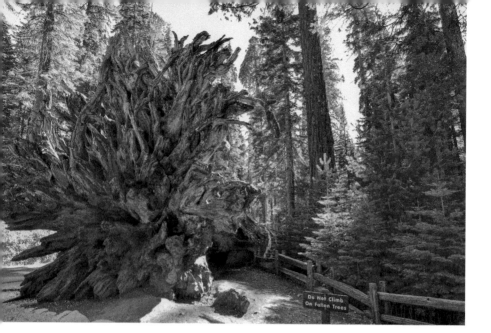

Fallen Monarch is a tree that fell more than three hundred years ago. Giant sequoias are resistant to decay, so their remains can linger for a long period of time if undisturbed.

✉ **Addr:**	4726 Mariposa Grove Rd, Fish Camp CA 93623	📍 **Where:**	37.502652 -119.608959
◑ **When:**	Morning	👁 **Look:**	South-southwest
📷 **Lens:**	28mm	W **Wik:**	Mariposa_Grove

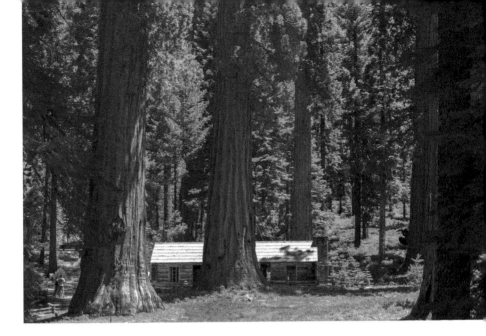

The **Mariposa Grove Museum** was built in 1930 and is a log cabin dwarfed by massive trees.

✉ **Addr:**	4726 Mariposa Grove Rd, Fish Camp CA 93623	📍 **Where:**	37.5134105 -119.5997939
◑ **When:**	Afternoon	👁 **Look:**	East
📷 **Lens:**	50mm	W **Wik:**	Mariposa_Grove#Mariposa_Grove_Museum

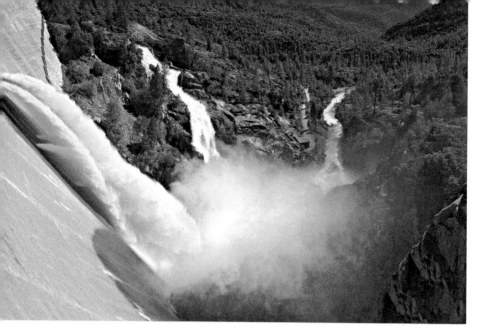

O'Shaughnessy Dam is a 430-foot high concrete arch-gravity dam, completed in 1923 to supply water to San Francisco.

The dam is at the lower end of Hetch Hetchy Valley, north of Yosemite Valley, about 12 miles (18 km) northeast from the Big Oak Flat entrance.

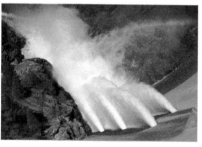
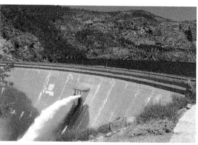

✉ **Addr:**	Evergreen Road, Groveland CA 95321	📍 **Where:**	37.948343 -119.788659	
◑ **When:**	Afternoon	👁 **Look:**	South-southeast	
📷 **Lens:**	28mm	W **Wik:**	O%27Shaughnessy_Dam_(California)	

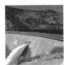

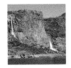

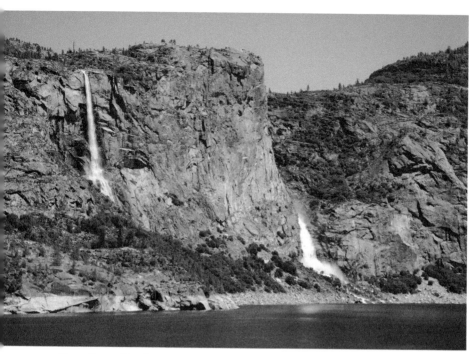

From the parking lot at the south end of the dam, you can photograph Tueeulala Falls (840 feet / 260 m) and Wapama Falls (1,080 feet / 330 m), both among the tallest waterfalls in North America. Along the south wall of the dam is the spillway.

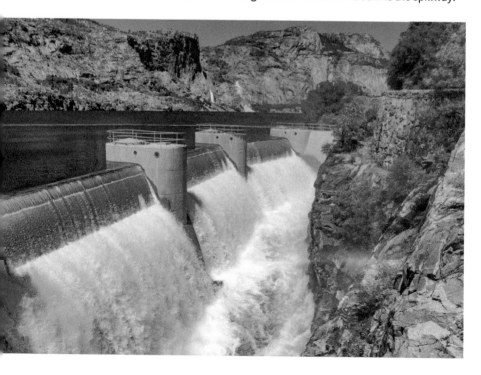

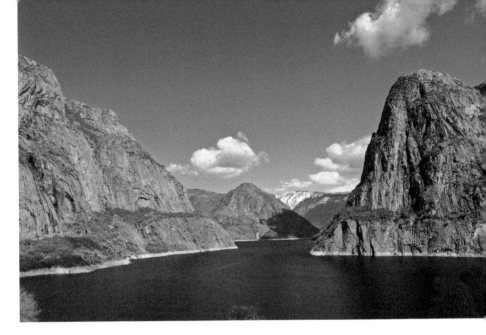

Kolana Rock is the most distinctive rock formation at Hetch Hetchy. The prominent granite dome is located along the southern edge of the valley. It towers 2,000 feet (610 m) above the Hetch Hetchy Reservoir, and is across from Hetch Hetchy Dome.

In 1870, Muir called Hetch Hetchy Valley "a wonderfully exact counterpart of the great Yosemite."

This view is from the Rancheria Falls Trail, just over a mile (1.7 km) north from the dam parking lot.

✉ **Addr:**	Hetch Hetchy Valley, Yosemite NP CA 95321	📍 **Where:**	37.9579573 -119.7837025
🌙 **When:**	Afternoon	👁 **Look:**	East-southeast
📷 **Lens:**	50mm	W **Wik:**	Kolana_Rock

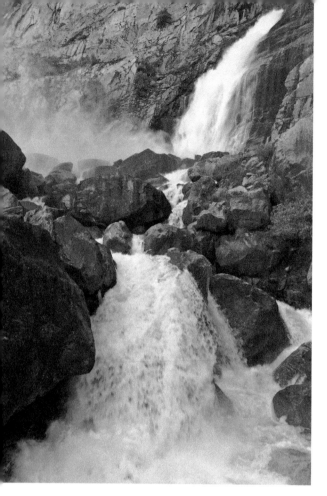

Wapama Falls is the larger of two waterfalls located on the northern wall of Hetch Hetchy Valley.

Like Yosemite Falls, Wapama Falls has three distinct parts: two large drops and a wide cascade, with a total drop of 1,080 feet (330 m). Stone steps and bridges that cross the creek make for good foregrounds.

You can reach the scenic area by hiking about 2.5 miles (4 km) from the dam, along the Rancheria Falls Trail. A similar distance beyond is Rancheria Falls, with a round-trip time of 6–8 hours.

✉ **Addr:**	Hetch Hetchy Valley, Yosemite NP CA 95321	♀ **Where:**	37.963458 -119.766018
☾ **When:**	Morning	◉ **Look:**	North
📷 **Lens:**	28mm	Ⱳ **Wik:**	Wapama_Falls

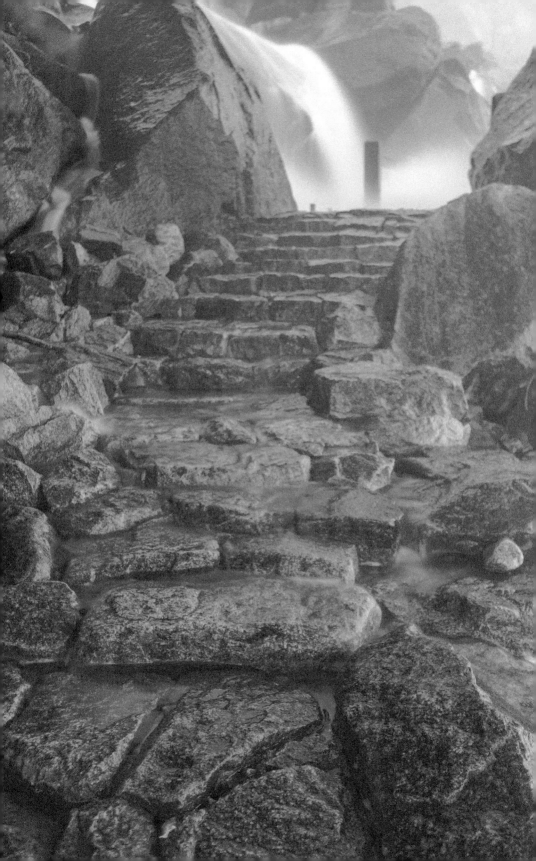

Wapama
Falls

Falls Cre

ils

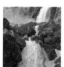 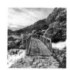

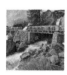

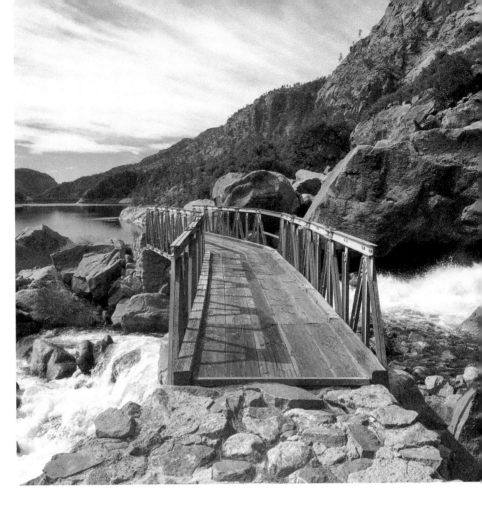

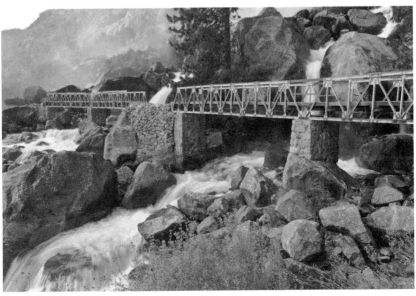

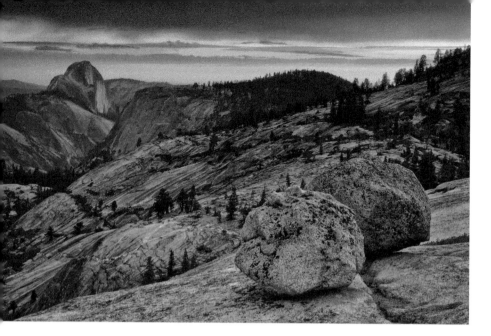

Olmsted Point is a viewing area off Tioga Road with a distant view of Half Dome. The site is named after landscape architects Frederick Law Olmsted and Frederick Law Olmsted, Jr., who helped protect Yosemite in 1860s.

The trailhead is at 8,300 feet (2,500 m) near Tenaya Lake, about 40 miles (65 km) drive from Yosemite Valley and 18 miles (29 km) from Tioga Pass. Note that Tioga Road is closed in winter.

✉ **Addr:**	Tioga Road, Yosemite Valley CA 95389	♀ **Where:**	37.81067 -119.48517
☾ **When:**	Sunset	👁 **Look:**	South-southwest
📷 **Lens:**	35mm	W **Wik:**	Olmsted_Point

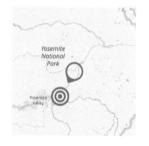

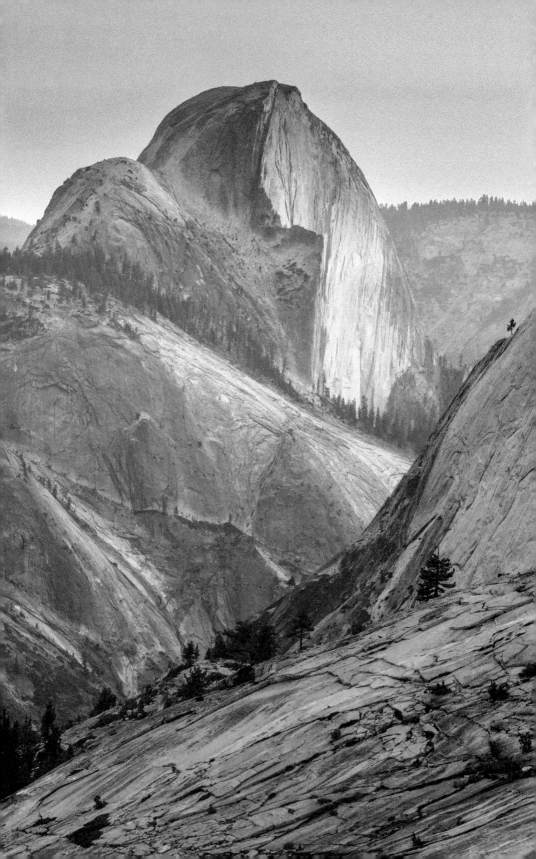

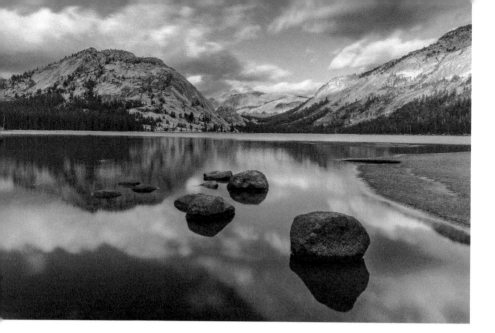

Tenaya Lake is an alpine lake between Yosemite Valley and Tuolumne Meadows. The surface an elevation of 8,150 feet (2,484 m) and the lake basin was formed by glacial action.

The lake is easily accessed from Tioga Road and this view is from the roadside, at a pullout and beach on the west side.

Tenaya Lake is named after the leader of the native inhabitants, Chief Tenaya, who protested that the lake already had a name: Pie-we-ack, or "Lake of the Shining Rocks."

✉ **Addr:**	Tenaya Lake Trail, Wawona CA 95389	♀ **Where:**	37.829683 -119.467554
◑ **When:**	Afternoon	👁 **Look:**	East-northeast
📷 **Lens:**	28mm	W **Wik:**	Tenaya_Lake

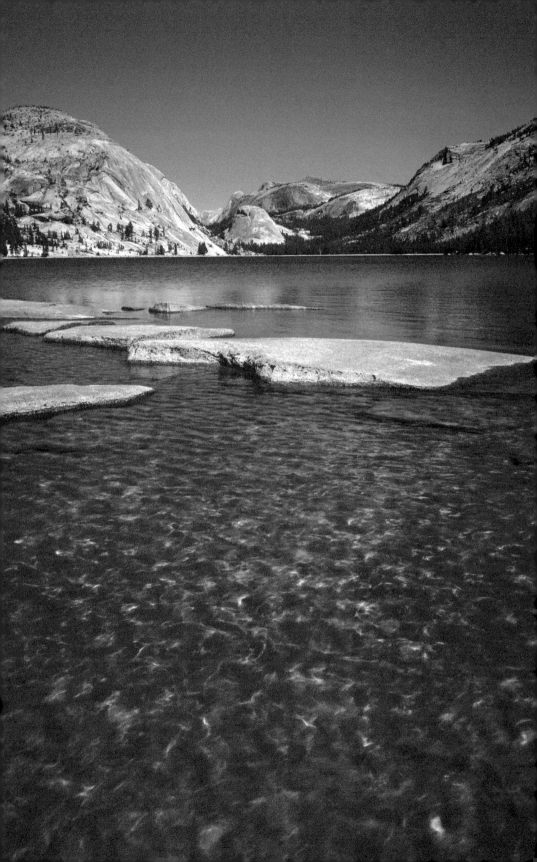

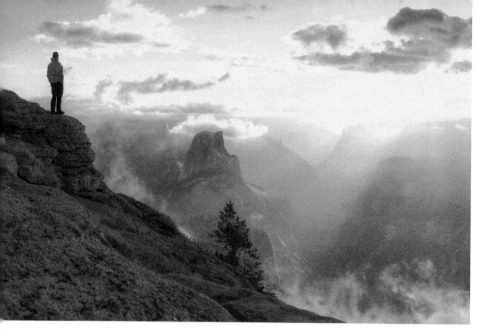

Half Dome from Clouds Rest is a rare view from above
Yosemite Valley's iconic rock. At 9,930 feet (3,027 m), Clouds Rest is over 1,000 feet (330 m) higher than Half Dome. The summit can be reached by a 7.2-mile (11.6 km) trail hike from Tioga Pass Road.

✉ **Addr:**	Sunrise Lakes Trail, Yosemite Valley CA 95389	♀ **Where:**	37.767853889 -119.489226925
☽ **When:**	Morning	◉ **Look:**	West-southwest
▢ **Lens:**	35mm	W **Wik:**	Clouds_Rest

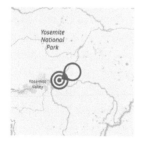 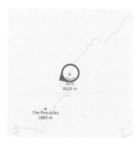 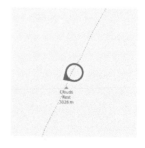

May Lake is another alpine lake but less accessible, requiring a 1.2 mile (1.9 km) hike from a parking area off Tioga Pass Road, north of Tenaya Lake. In the background is Mount Hoffmann.

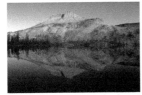

The mountain is named for (and by) cartographer Charles F. Hoffmann of the California Geological Survey of the Sierra Nevada. Hoffman named the lake for his fiancée, Lucy Mayotta ("May") Browne. The benefits of making maps.

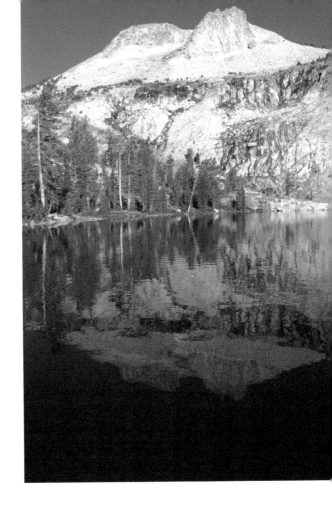

✉ **Addr:**	Tioga Road, Yosemite Valley CA 95389	♀ **Where:**	37.845787 -119.4910593
◑ **When:**	Morning	◉ **Look:**	West
📷 **Lens:**	50mm	W **Wik:**	May_Lake_(California)

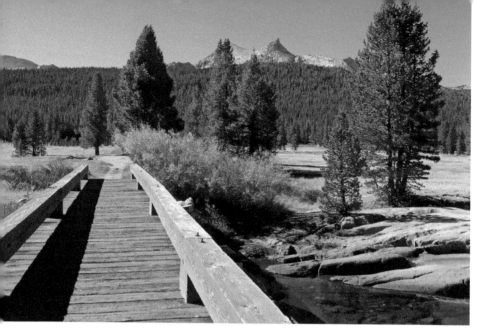

Tuolumne Meadows is a gentle, dome-studded, sub-alpine meadow area along the Tuolumne River in the eastern section of Yosemite National Park. This view is of the pedestrian bridge crossing the creek. Within walking distance are Soda Springs and Parsons Memorial Lodge.

✉ **Addr:**	Tioga Road, Yosemite NP CA 95321	♀ **Where:**	37.877208 -119.366208
◑ **When:**	Afternoon	👁 **Look:**	North
📷 **Lens:**	28mm	W **Wik:**	Tuolumne_Meadows

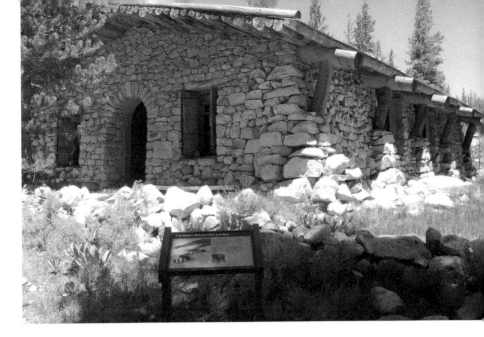

The **Parsons Memorial Lodge** at the northern end of Tuolumne Meadows is one of the earliest stone buildings in a National Park, built in 1915 by the Sierra Club.

The lodge is a memorial to Edward Taylor Parsons, a New Yorker who joined the Sierra Club about 1900, becoming the club's director from 1905 to 1914. Parsons was heavily involved in the losing fight against the flooding of the Hetch Hetchy Valley to provide a municipal water source for San Francisco. Parsons died in 1914, and in memorial the Sierra Club established a fund to build a club meeting house, library and headquarters in Yosemite. The site at Tuolumne Meadows was chosen for its accessibility to park backcountry and its location near Soda Springs, a location that the Sierra Club wished to safeguard.

✉ **Addr:**	Yosemite National Park Rd, Wawona CA 95389	♀ **Where:**	37.878258 -119.367293
❓ **What:**	Building	☽ **When:**	Morning
👁 **Look:**	Northwest	W **Wik:**	Parsons_Memorial_Lodge

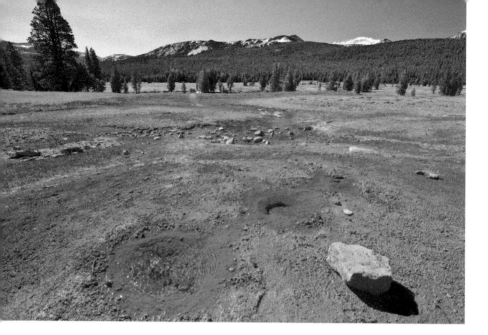

Soda Springs are mineral springs in Tuolumne Meadows, at 8,600 feet (2,600 m). There is a small cabin built in 1889 by John Baptist Lembert, the first European settler on the Tuolumne Meadows, to prevent his flock of angora goats from damaging the area.

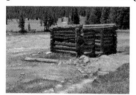

✉ **Addr:**	Sierra High Rte, Yosemite NP CA 95389	♀ **Where:**	37.878889 -119.365556	
◑ **When:**	Anytime	👁 **Look:**	West	
📷 **Lens:**	50mm	W **Wik:**	Soda_Springs_(Yosemite_National_Park)	

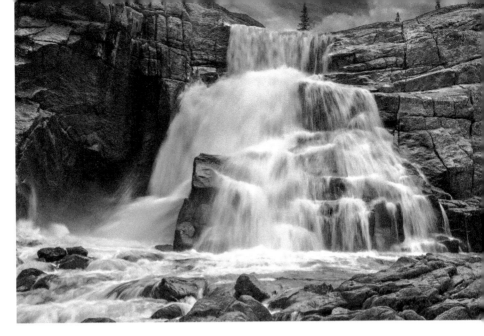

Tuolumne Falls is the first major waterfall from Tuolumne Meadows towards the Grand Canyon of the Tuolumne River. About half a mile (800 m) further downstream is **White Cascade**, also called Glen Aulin Falls. Summer hikers will appreciate the cool pool at the base.

The hike is about four miles (6 km) from the trailhead. To make a day of it, you can continue on to California Fall (13 miles roundtrip), LeConte Fall (15 miles roundtrip), and Waterwheel Falls (18 miles roundtrip). The return hike follows the same route.

✉ **Addr:**		♀ **Where:**	37.9061762 −119.4182264
❓ **What:**	Waterfall	☽ **When:**	Afternoon
👁 **Look:**	Southeast	↔ **Far:**	70 m (220 feet)

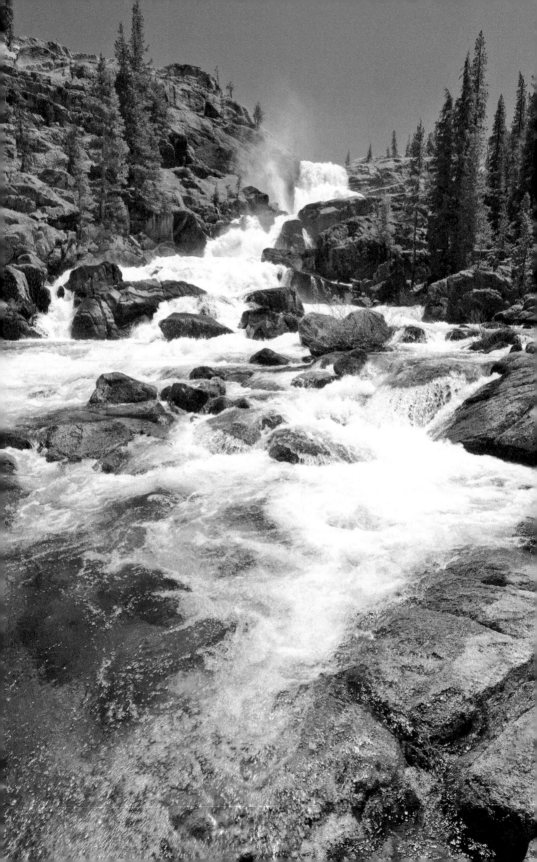

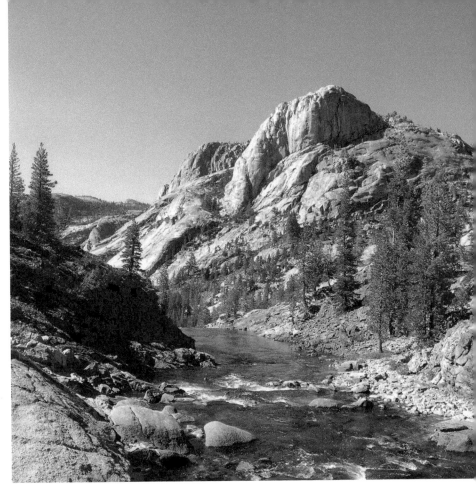

Cold Canyon is a few hundred feet (100 m) downstream from White Cascade, by the Glen Aulin High Sierra Camp.

✉ **Addr:**	Glen Aulin, Yosemite NP CA 95321	♀ **Where:**	37.9107931 -119.42145332	
☽ **When:**	Afternoon	👁 **Look:**	South-southeast	
📷 **Lens:**	35mm	W **Wik:**	Glen_Aulin	

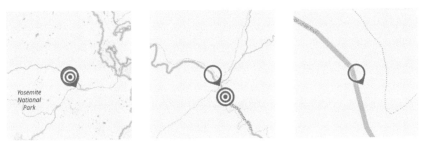

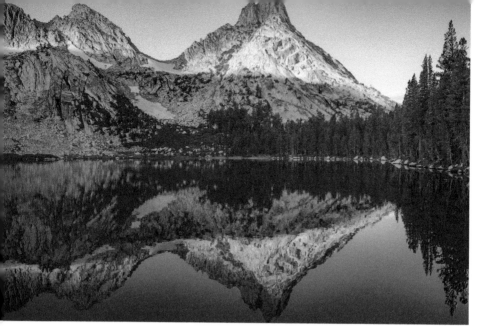

Upper Young Lake and Ragged Peak is a view of the
prominent 10,912 ft (3,326 m) mountain. This shot was taken at sunrise.

The lake is reached by a hike of about seven miles (10 km) from Parsons Lodge.

✉ **Addr:**	Tioga Road, Lee Vining CA 93541	♥ **Where:**	37.9375493 -119.3451215	
◑ **When:**	Sunrise	👁 **Look:**	Southwest	
📷 **Lens:**	35mm	W **Wik:**	Ragged_Peak_(Yosemite_National_Park)	

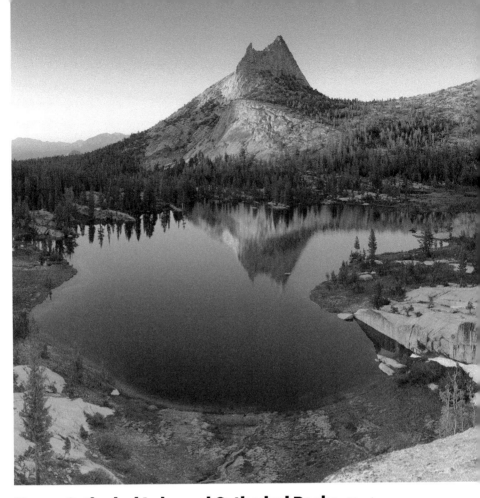

Upper Cathedral Lake and Cathedral Peak in Tuolumne

Meadows, south of Tioga Road. The John Muir Trail is nearby, with a 7 miles (11 km) round trip hike from the trailhead in Tuolumne Meadows.

✉ **Addr:**	Tioga Road, Yosemite NP CA 95389	♀ **Where:**	37.838318 -119.41716
☽ **When:**	Sunrise	◉ **Look:**	Northeast
◉ **Lens:**	28mm	W **Wik:**	Cathedral_Lakes

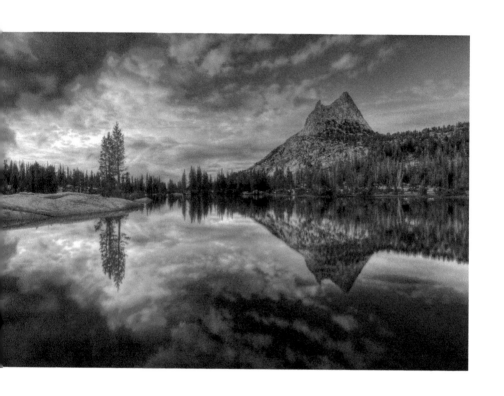

9 East Park / Tioga Road > Tuolumne Meadows area > south of Tioga Road > Cathedral Lakes > Upper Cathedral Lake > Upper Cathedral Lake and Cathedral Peak

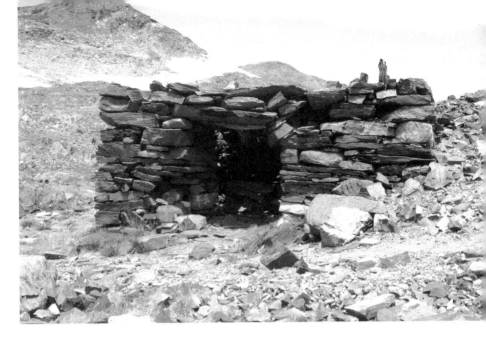

The **Great Sierra Mine Historic Site** preserves the site of the largest mining operation in what would become Yosemite National Park. The mine was located on Tioga Hill on the crest and eastern slope of the Sierra Nevada to work the Sheepherder silver lode. In 1881, the company town of Dana was built at an elevation of 11,000 feet. Today, five stone cabins, a powder house and a blacksmith shop remain.

The mine site is reached by a hike of about two miles (3 km) north from Tioga Pass, along the Gaylor Lake Trail.

✉ **Addr:**	Gaylor Lake Trail, Lee Vining CA 93541	📍 **Where:**	37.92750 -119.26806
🕐 **When:**	Morning	👁 **Look:**	Southwest
📷 **Lens:**	50mm	W **Wik:**	Great_Sierra_Mine_Historic_Site

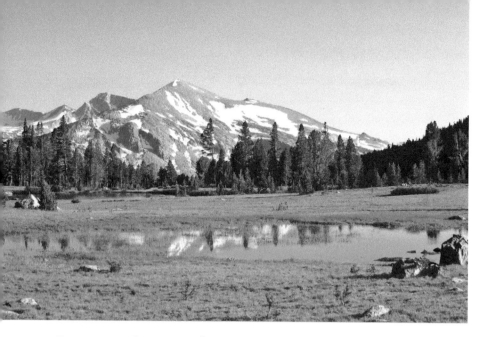

Dana Meadows at Tioga Pass is a roadside view from the

Dana Meadows at Tioga Pass is a roadside view from the highest paved mountain pass in California. At an elevation of 9,943 feet (3,031 m), Tioga Pass is closed when there is snow, typically from early November to late May. From here you can see Mount Dana, Mammoth Peak and the Kuna Crest.

Tioga Pass is the only eastern entrance to Yosemite National Park, and a good place to end our tour of the photographic highlights of Yosemite.

✉ **Addr:**	Tioga Road, Lee Vining CA 93541	♀ **Where:**	37.908425 -119.258174
☽ **When:**	Afternoon	👁 **Look:**	South
◉ **Lens:**	50mm	W **Wik:**	Tioga_Pass

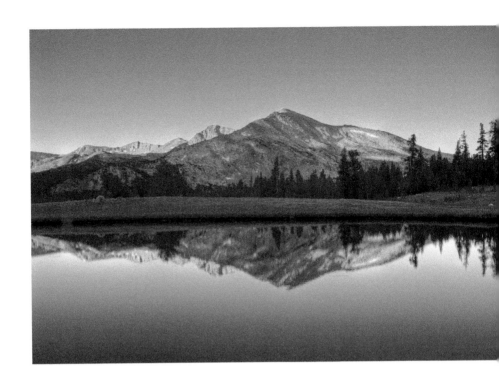

ⓘ Sunrise and Sunset Times

	Sunrise	Sunset
Jan 1	7:13am	4:48pm
Jan 15	7:12am	5:01pm
Feb 1	7:02am	5:20pm
Feb 15	6:48am	5:35pm
Mar 1	6:29am	5:51pm
Mar 15	7:08am	7:04pm
Apr 1	6:42am	7:20pm
Apr 15	6:22am	7:33pm
May 1	6:02am	7:47pm
May 15	5:48am	8:00pm
Jun 1	5:38am	8:13pm
Jun 15	5:36am	8:20pm
Jul 1	5:41am	8:23pm
Jul 15	5:49am	8:19pm
Aug 1	6:03am	8:06pm
Aug 15	6:15am	7:50pm
Sep 1	6:29am	7:27pm
Sep 15	6:41am	7:06pm
Oct 1	6:54am	6:41pm
Oct 15	7:07am	6:20pm
Nov 1	7:24am	4:59pm
Nov 15	6:39am	4:46pm
Dec 1	6:55am	4:39pm
Dec 15	7:07am	4:40pm

Credits

Thank you to the many wonderful people and companies that made their work available to use in this guide.

Photo key: The number is the page number. The letters reference the position on the page, the distributor and the license. Key: a:CC-BY-SA; b:bottom; c:center; d:CC-BY-ND; e:CC-PD; f:Flickr; h:Shutterstock standard license; l:public domain; s:Shutterstock; t:top; w:Wikipedia; y:CC-BY.

Cover image by Lynn Yeh/Shutterstock. Back cover image by Alarax/Shutterstock. Other images by: Eb Adventure (119t sh); Alxcrs (58t sh); Galyna Andrushko (26t fy); Dimitry B. (109t sh); Ruben Martinez Barricarte (108t, 108 sh); Matthew Baugh (30t sh); Bill45 (25, 76 sh); Robert Bohrer (68t, 150, 156t, 157, 158, 164t sh); Jeremy Borkat (122t, 123 sh); Sasha Buzko (40t sh); Canadastock (23c, 43b sh); Francesco Carucci (139t sh); Steven Castro (132 sh); Ferenc Cegledi (133 sh); Checubus (20, 44t, 45, 118t sh); Engel Ching (110 sh); Chintla (35 sh); Patrick Civello (142b sh); Sebastian Craik (92b sh); Gary Ctognoni (73t sh); Curtis (157t sh); Dancestrokes (82t, 92 sh); Simon Dannhauer (56, 93, 94 wy); Dave (117 sh); Danita Delmont (34t, 41, 148t sh); Diegomezr (26 sh); Celso Diniz (69 sh); Eugene Domejes (89 sh); Megan Drescher (20 fy); Chris Eason (109 fy); Robert Engberg (116t sh); Greg Epperson (99t sh); John Erskine (52 sh); F11photo (31 sh); Sarah Fields (32t, 53, 81t, 81, 87t sh); Anton Foltin (98, 140t sh); Fremme (97 sh); Filip Fuxa (103t wa); Gowittylb (155t, 156 fa); Don Graham (154t fa); Grard (137 wl); J Malcolm Greany (75 sh); Beihua Steven Guo (20t, 27 sh); Mariusz Hajdarowicz (114 sh); Haveseen (24, 48 sh); Xavier Hoenner (68 sh); Nido Huebl (138t sh); Ianinthewild (91 wa); David Iliff (68, 95t sh); Tangent Imagez (84 wa); Inklein (140 sh); Javen (30, 77, 120t sh); Jayjm (104t, 105 sh); Jk (29 sh); Jody (71b sh); Paul R. Jones (126t wy); Spencer Joplin (100 sh); Aarti Kalyani (125 fa); Michael Karagosian (153 sh); Kenneth Keifer (115 sh); Kenggo (121 sh); Jeffrey Kreulen (52t sh); Jeffrey T. Kreulen (165t fy); Thomas Kriese (107 sh); Yongyut Kumsri (136 sh); Katrina Leigh (22c, 48t, 48 sh); Doug Lemke (151 sh); Co Leong (59, 61, 65t sh); Kit Leong (71c, 78, 80t, 80c, 80b fy); Chase Lindberg (22t, 58 wa); Kenneth Liou (160t sh); Malgorzata Litkowska (128t, 128 sh); Littlenystock (78t sh); Lorcel (63t sh); Lunamarina (130 sh); Geir Olav Lyngfjell (113b wy); Ronnie Macdonald (120 sh); Maridav (58, 92t sh); Victor Maschek (39 wy); David Mccracken (153t fa); Bonzo Mcgrue (101 sh); Tyler Meester (100t sh); Megapixel (161t sh); Stephen Moehle (38t, 38, 76t, 100, 112b fa); Moonjazz (57b sh); Anna Morgan (86, 160 fy); Barney Moss (49 fd); Chris Murphy (54t wa); Mike Murphy (135 sh); N8allen (122, 124t sh); Doug Oglesby (148 sh); Omiksovsky (43t sh); Pugventure Photo (152t, 152 sh); Photocritical (147t sh); Pixelshop (33, 51 sh); Pmmrd (114t sh); Goldilock Project (71t sh); Pung (22b, 39t sh); Alex Radelich (28 sh); Reimar (28t sh); Radomir Rezny (57t sh); Jane Rix (129c, 131 sh); Jeffrey B. Ross (143 sh); Ruiz460 (150t sh); Andrew S (21, 25t, 36 sh); Gary Saxe (140, 142t fa); Screaming_monkey (126 fe); Stefan Serena (92 wl); National Park Service (163t wy); Angela Sevin (159t sh); Sierralara (162c sh); Nelson Sirlin (64 sh); Roel Slootweg (88t sh); Kenneth Sponsler (24t, 134t fd); Paul Sullivan (65 sh); Phitha Tanpairoj (46t, 46 fa); Jc Tennis (74t sh); Gary Tognoni (35t sh); Tomkli (62t sh); Travelview (130t sh); Tusharkoley (72t sh); Zhukova Valentyna (66 sh); Kelly Vandellen (145 sh); V_e (113t fy); Justin Vidamo (132t wa); Wearsunscreen (127t sh); Kris Wiktor (112t fa); Erik Wilde (106t sh); Invisible Witness (103 sh); Lynn Yeh (42t, 50t, 136t sh); Colin Young (125t sh); Colin D. Young (143t, 144t, 147b sh); Andrew Zarivny (83t sh); Bildagentur Zoonar (149 sh).

Some text adapted from Wikipedia and its contributors, used and modified under Creative Commons Attribution-ShareAlike (CC-BY-SA) license. Map data from OpenStreetMap and its contributors, used under the Open Data Commons Open Database License (ODbL).

This book would not exist without the love and contribution of my wonderful wife, Jennie. Thank you for all your ideas, support and sacrifice to make this a reality. Hello to our terrific kids, Redford and Roxy.

Thanks to the many people who have helped PhotoSecrets along the way, including: Bob Krist, who answered a cold call and wrote the perfect foreword before, with his wife Peggy, becoming good friends; Barry Kohn, my tax accountant; SM Jang and Jay Koo at Doosan, my first printer; Greg Lee at Imago, printer of my coffe-table books; contributors to PHP, WordPress and Stack Exchange; mentors at SCORE San Diego; Janara Bahramzi at USE Credit Union; my bruver Pat and his family Emily, Logan, Jake and Cerys in St. Austell, Cornwall; family and friends in Redditch, Cornwall, Oxford, Bristol, Coventry, Manchester, London, Philadelphia and San Diego.

Thanks to everyone at distributor National Book Network (NBN) for always being enthusiastic, encouraging and professional, including: Jed Lyons, Jason Brockwell, Kalen Landow (marketing guru), Spencer Gale (sales king), Vicki Funk, Karen Mattscheck, Kathy Stine, Mary Lou Black, Omuni Barnes, Ed Lyons, Sheila Burnett, Max Phelps, Jeremy Ghoslin and Les Petriw. A special remembrance thanks to Miriam Bass who took the time to visit and sign me to NBN mainly on belief.

The biggest credit goes to you, the reader. Thank you for (hopefully) buying this book and allowing me to do this fun work. I hope you take lots of great photos!

© Copyright

PhotoSecrets Yosemite, first published June 15, 2019. This version output May 17, 2019.

ISBN: 978-1930495661. Distributed by National Book Network. To order, call 800-462-6420 or email customercare@nbnbooks.com.

> *"'And what is the use of a book,' thought Alice*
> *'without pictures or conversations?'"*
> — *Alice's Adventures in Wonderland, Lewis Carroll*

© Copyright

⚒ Disclaimer

The information provided within this book is for general informational purposes only. Some information may be inadvertently incorrect, or may be incorrect in the source material, or may have changed since publication, this includes GPS coordinates, addresses, descriptions and photo credits. Use with caution. Do not photograph from roads or other dangerous places or when trespassing, even if GPS coordinates and/or maps indicate so; beware of moving vehicles; obey laws. There are no representations about the completeness or accuracy of any information contained herein. Any use of this book is at your own risk. Enjoy!

✉ Contact

For corrections, please send an email to andrew@photosecrets.com. Instagram: photosecretsguides; Web: www.photosecrets.com

⬛ Index

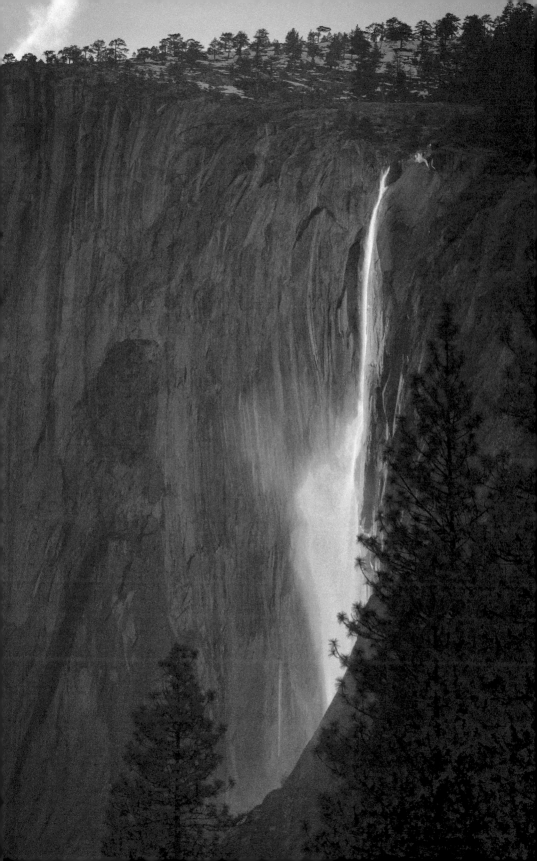

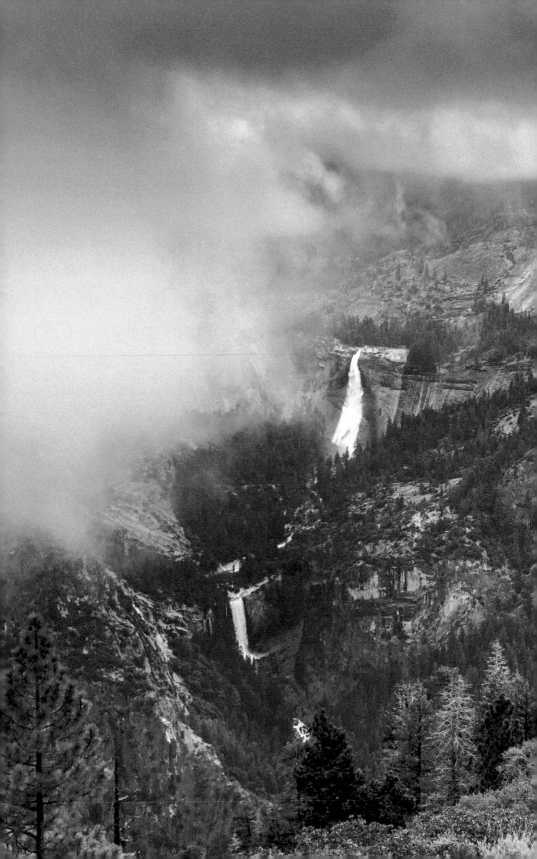

THANK YOU for reading PhotoSecrets. I like to start books by flicking from the back cover, so this is a good place for a welcome message.

As a fellow fan of travelling with a camera, I hope this guide will quickly get you to the best spots so you can take postcard-perfect pictures.

PhotoSecrets shows you all the best sights. Look through, see the classic shots, and use them as a departure point for your own creations. Get ideas for composition and interesting viewpoints. See what piques your interest. Know what to shoot, why it's interesting, where to stand, when to go, and how to get great photos.

Now you can spend less time researching and more time photographing.

The idea for PhotoSecrets came during a trip to Thailand, when I tried to find the exotic beach used in the James Bond movie *The Man with the Golden Gun*. None of the guidebooks I had showed the beach, so I thought a guidebook of postcard photos would be useful. Twenty-plus years later, you have this guide, and I hope you find it useful.

Take lots of photos!

Andrew Hudson

Andrew Hudson started PhotoSecrets in 1995 and has published 22 nationally-distributed color photography books. His first book won the Benjamin Franklin Award for Best First Book and his second won the Grand Prize in the National Self-Published Book Awards.

Andrew has photographed assignments for *Macy's, Men's Health* and *Seventeen*, and was a location scout for *Nikon*. His photos and articles have appeared in *National Geographic Traveler, Alaska Airlines, Shutterbug, Where Magazine*, and *Woman's World*.

Born in England, Andrew has a degree in Computer Engineering from the University of Manchester and was previously a telecom and videoconferencing engineer. Andrew and his wife Jennie live with their two kids and two chocolate Labs in San Diego, California.